PERFECTLY CANDID

To
Ann & Ed.
all good wishes.

Pamela Rankin-Smith

Published by Light Scape Editions imprint of Station Hill Press, Inc., Barrytown, New York 12507
Distributed by The Talman Company, 131 Spring St. Suite 201E-N, New York, New York 10012

Library of Congress Catalog Card Number 93-093671
ISBN 0-88268-150-8

PAMELA RANKIN-SMITH

Perfectly Candid

PREFACE
Vann Witcher

CAPTIONS
Sanford Dody

C o n t e n t s

acknowledgment

My earnest gratitude to my dear friend C. C. Wang
for creating the end leaves of this book.

P. R. S., winter 1992

Preface

Family legend has it that Pamela borrowed her father's Kodak Brownie Box camera when she was hardly more than a little girl and hasn't stopped taking pictures since. I guess I've seen every one of the hundreds of thousands of photos she's taken. As far as I can remember, with very few exceptions, they are all pictures of people. Now that I think of it, there was a short period when her attention turned to animals -- or to certain parts of animals! It started one day when she shot (photographically) my large, shaggy, white dog climbing into our rural mail box where Pamela had hidden a bone. From there she started shooting the rear ends of less domestic beasts -- hippos, elephants, giraffes and any other callipygous mammals she could approach from behind. She called the series, without ceremony, ("Asses.")

Aside from this brief interlude, photos of people remain what she most likes to do and what she does best. Her portraits are mostly "candid". She has a puckish nature and loves "catching people in the act."

The story of the photographs in this book encompasses more of Pamela's nature than her passion for photography. However, it is the story of how her dedication to the arts in general has afforded her access to many of the greatest celebrities of our time. This dedication involves musical training and connoisseurship, experience with various aspects of the visual arts, and a highly developed dexterity at a number of handicrafts. By the time she graduated from high school she had won a reputation for being an excellent pianist as well as a certain notoriety for wearing outlandish clothes that in fact she had designed and made herself. She retains her love of music, though she seldom plays anymore; and while she has considerably toned down the character of her preferences over the years, she still does prefer to rip, cut and sew something old in order to refurbish and make it fashionable, rather than purchasing the latest fashions.

At the University of Texas, drama became her first love. When she moved to New York City in 1950, with a young son, it was to the theatre that she was drawn. She joined Actors' Equity (to which she still belongs) and enjoyed a brief acting career. Acting did not become her major calling, however, and she was forced to make a living.

While thus occupied with mundane employment, her love of music and the theatre never waned, even though the fifties when her only luxury was a weekly seat in the balcony of the theatre or concert hall.

Circumstances changed considerably for Pamela in 1960. She met and later married A. Arthur Smith. Straightaway she began to sit in the orchestra -- and more than once a week! Her marriage was gratifying and eventful for Arthur shared her love for the arts. Together they went to the opera, ballet, concerts, lectures and the theatre. They traveled and frequented the museums, concert halls and theatres of Europe. Their marriage was sweet but all too short, for Arthur was to live for only a few years more.

After the death of her husband, Pamela decided to devote herself to the practical study of several of the arts that had, up to that time, occupied her as hobbies or passive avocations. She began by seeking out the best teachers to refine her obvious talents in photography. She studied with Ansel Adams and George A. Tice at The International Center for Photography in New York City and the quality of her finished prints began to improve in quantum leaps. But her improved technique only brought out qualities in her work that had really been there all along: a well-honed sense of the moment, a knack for capturing an expression, that special instinct for just when to click the shutter. She began using a light-body 35 mm Minolta and a Nikon with 200 mm or longer lenses, equipment designed for spontaneous shooting and for close-up work shot at a distance so she could avoid interfering or influencing her subjects.

In addition to Photography she studied Calligraphy, Oriental Painting, Ikebana and Decoupage. She volunteered her services to cultural institutions such as The Metropolitan Opera and The Metropolitan Museum of Art. She studied and practiced incessantly. Her talent blossomed and began to bear fruit. She was nominated to and accepted membership in many prestigious organizations such as Photographic Administrators, Inc., The National Arts Club, and The Circle of Confusion. She was asked to exhibit her photographic work in group and later one-man shows at Nikon House, The New York Camera Club, The Overseas Press Club, and many more galleries here and abroad. In recent years she has been making Ikebana flower arrangements for the Patrons Lounge at The Metropolitan Museum of Art and photographing each one.

Pamela has her (generally productive) eccentricities. A life long advocacy of vitamins and health food has certainly contributed to her vibrant health -- this and the fact that she relies on her own two feet, sometimes supplemented by her bicycle, to get around town. Her vices, if you would call them that, are frothy cappuccino and fine chocolate. She owns no VCR -- not even a TV -- and neither car nor microwave.

It's only natural that some of Pamela's portraits are of people she has come to know and admire. Often her photos are taken at performances or lectures, sometimes at charity banquets, though some of the more intimate images were made in a select, personal setting. For example, Sissy Spacek's mother, Virginia, was Pamela's childhood friend. Sissy and her Mom came to visit one day and Sissy's photo was taken in Pamela's living room. Vladimir Horowitz's photo was taken in Kent, Connecticut. When she later showed it to him, he autographed it. Vladimir's autograph opened up a new chapter in Pamela's photographic life -- not that autographs were something new to her. She has a drawer full of autographed programs collected over the years. In fact, I remember being given as a child an autograph album that I was commissioned to take with me when we went to performances. She'd send me scurrying back stage to get it signed.

After Horowitz, the idea of having her photos autographed struck home. She devised the plan of mailing the photo to the celebrity together with a return envelope and a letter requesting that it be autographed and returned . This process was productive, though an occasional photo would be damaged in the mail when of an overseas subject, as was the case with Anwar Sadat and Indira Ghandi. Through-the-mail autograph hunting has yielded probably a thousand autographed photos and it has proved a delicate and arduous task to make a choice for this book, thus, Pamela's plans are to publish a sequel in 1995. This book is but a small sampling of her favorites. Photographing celebrities has been a great adventure for Pamela, with its usual share of misadventures -- malfunctioning equipment, broken cameras, and bad film at one-in-a-lifetime opportunities; having her film ripped from her camera at the 92nd Street Y when Mary McCarthy's "bodyguards" or whatever they were, stopped her short with a gruff NO PICTURES; and even being physically ejected from Lincoln Center during a Barbara Stanwyck event when two policemen brusquely escorted her strong arms under gentle armpits, off the premises.

Late one evening we were interrupted by a phone call. After a moment Pamela looked at me and said, "There's a man on the phone desperate for a photographer. He says he has a date with Madonna! He's sending his limo to picks us up and go to the Palladium where he's supposed to meet her. Do you want to go?" "Sure."

The limo picked us up. We arrived at the Palladium and were escorted past a long line of elaborately costumed people waiting to get in. Inside was a crowded mass of humanity festooned in sequined bodysuits, feathers, and skin-tight leathers, adorned with implements of destruction. The din of the music was painful. The bass beat vibrated in everything and reverberated in our bones. The lights strobed and pulsed like the epileptic seizures of which they are famously the case. We proceeded, locked arm in arm, knowing full well that if separated, we'd never see each other again. A wave of bodies jostled us as they ran past screaming, "Eddie Murphy's here!" But no Madonna! By 1 a.m. we were saturated with the lights, music and Perrier. But no Madonna! At 3 a.m. we told our pudgy patron we had to leave. Still no Madonna. We left without any photos, but one hell of a story to tell my kids.

One of the great blessings life can bestow is to enjoy one's work. For Pamela, it's been just plain pleasure. It's her way of keeping more of those special moments alive than just the memory.

AARON COPLAND

Appalachia, the wild and woolly west. Dos 'a Dos. America
was so young once.

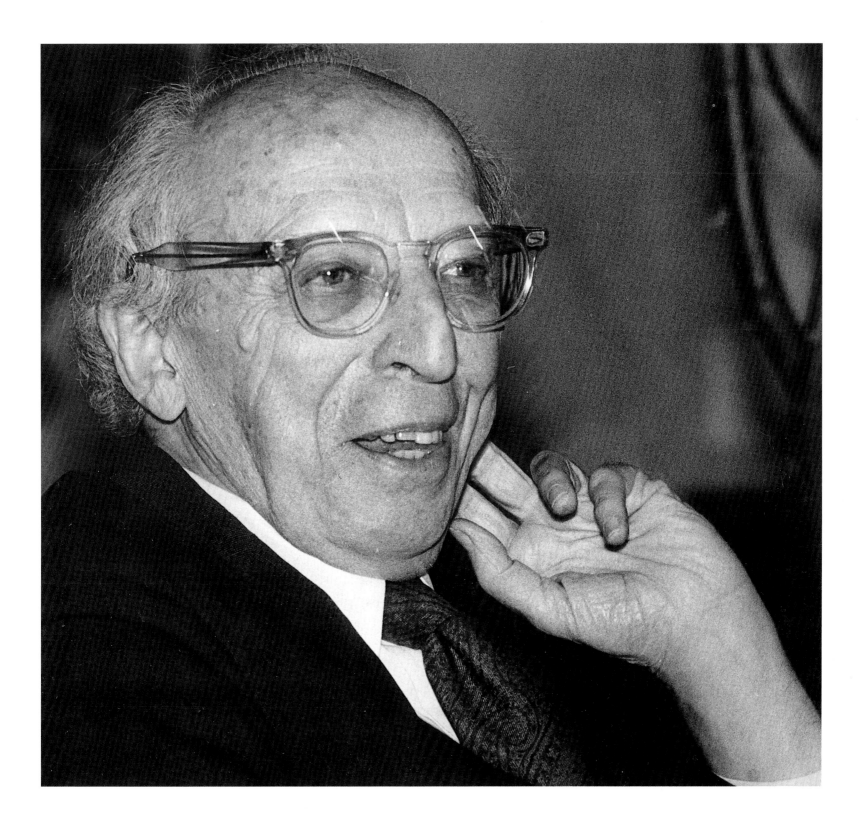

Aaron Copland

AL PACINO

Intense, scary, spontaneously combustive.

To Pamela
Best Wishes,

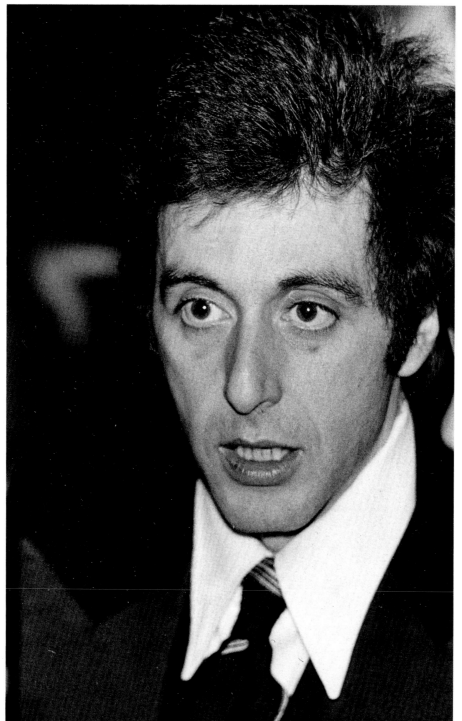

Al Pacino

ANDY WARHOL

No one seems to know that his fifteen minutes are up.

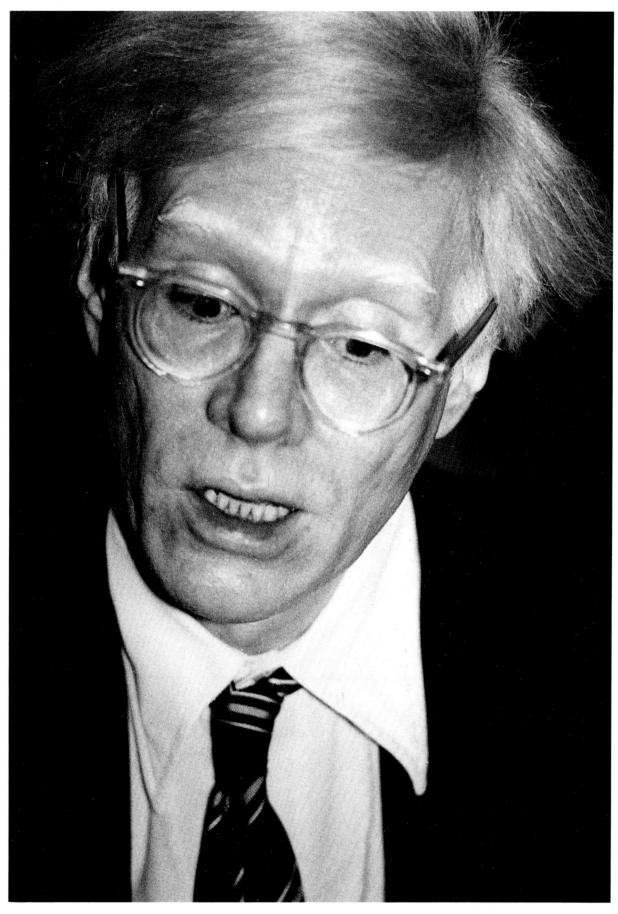

BETTE DAVIS

A.K.A. Doriana Gray. Brilliant and humorless.
She devoured herself in rage long before her final illness carried her off.

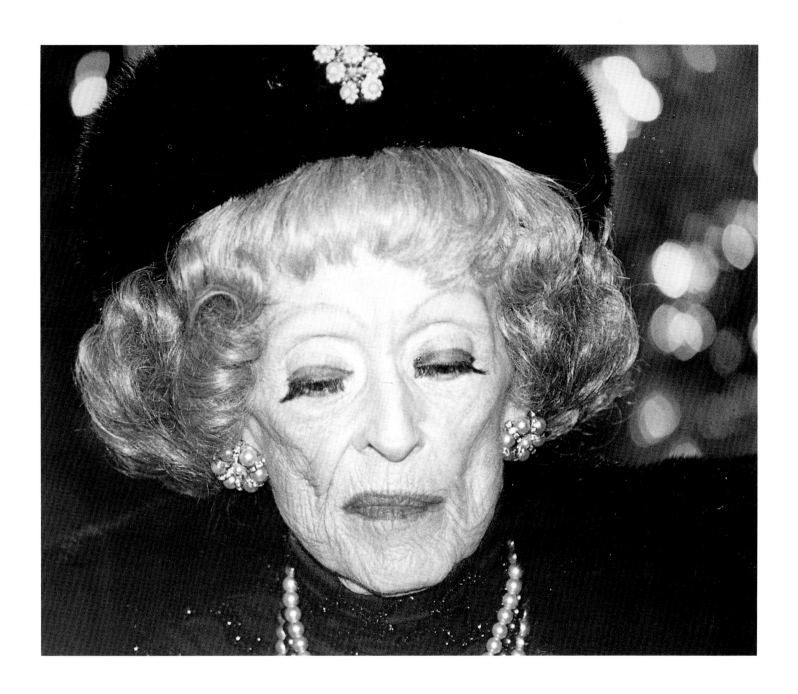

BOB HOPE

The memory is fading but he evidently will not.
As long there is war or skirmish, he'll be there.

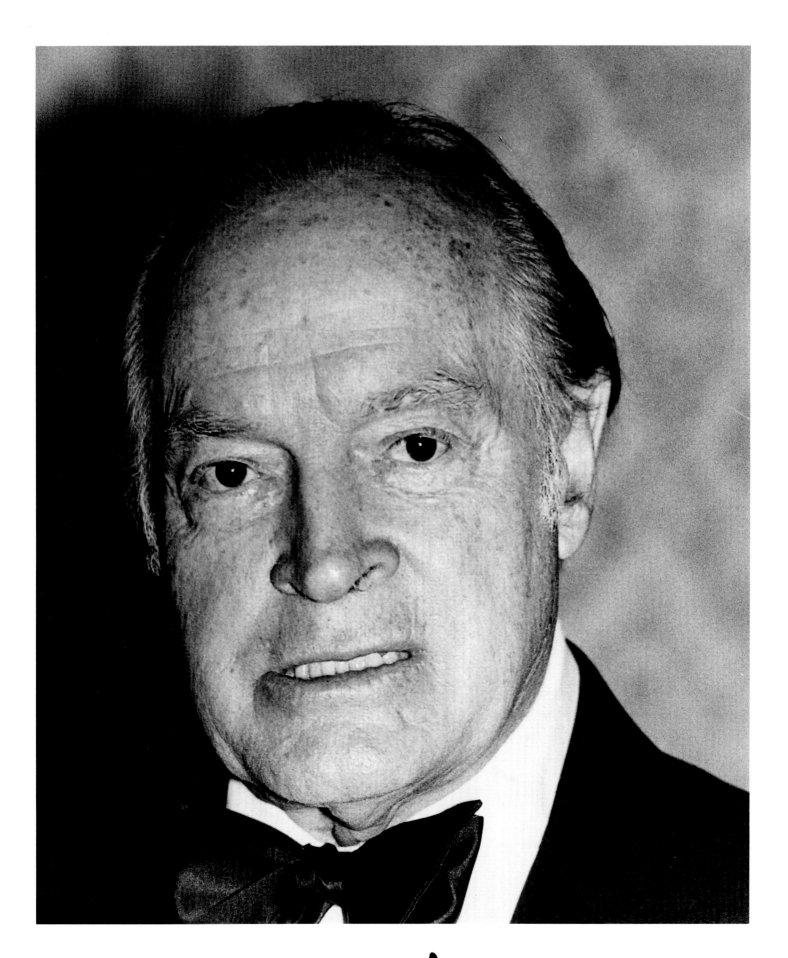

She had her special island - for a while anyway.

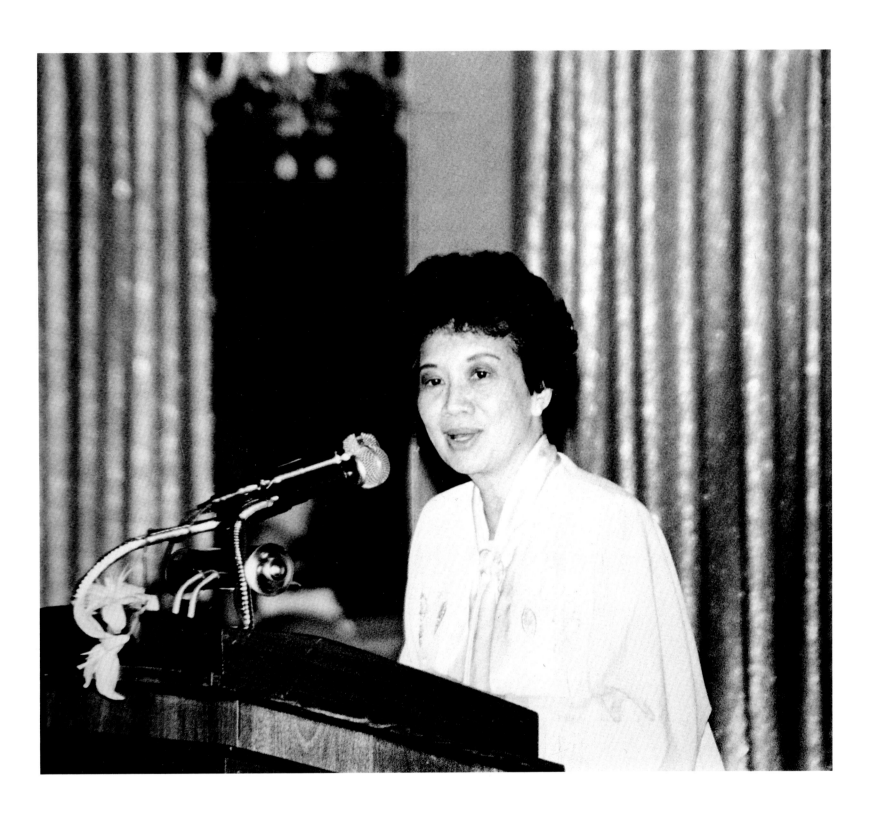

ARTHUR MILLER

Perhaps the greatest, perhaps the last Broadway playwright.

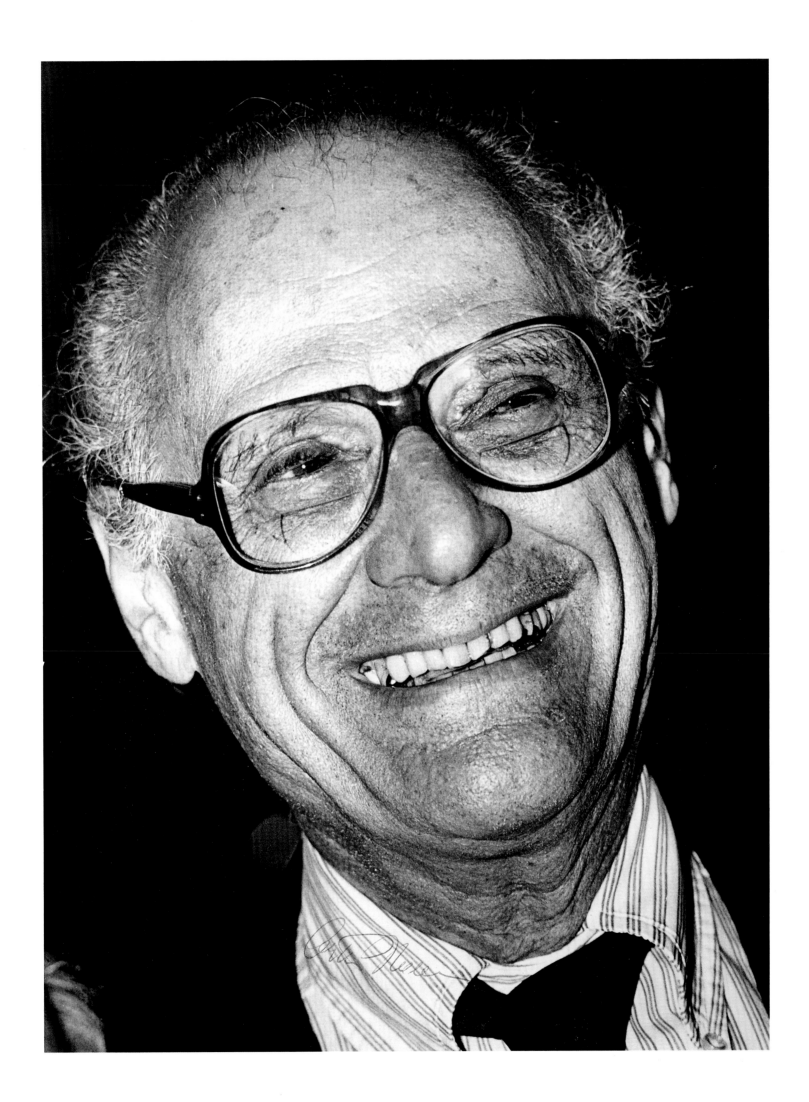

CYNTHIA GREGORY

No Oriole here, but Stravinsky's flaming,
ravishing firebird to the last feather.

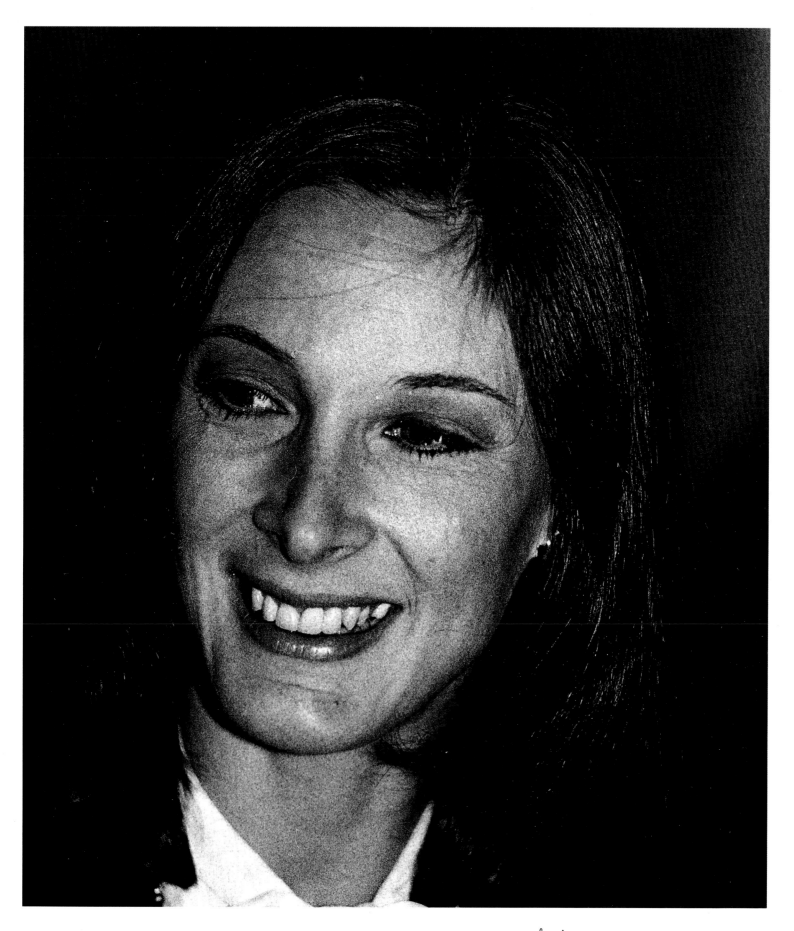

Among the stars, the dark side of the moon.

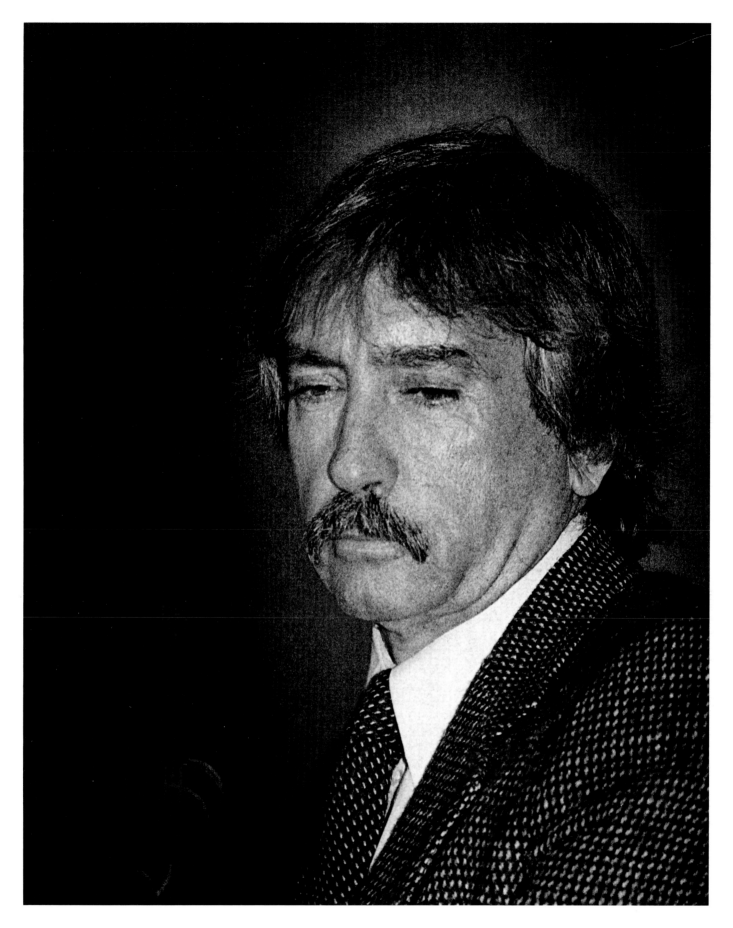

1986

JIMMY CARTER

Relentless perseverance in the service of mankind,
whatever the job title.

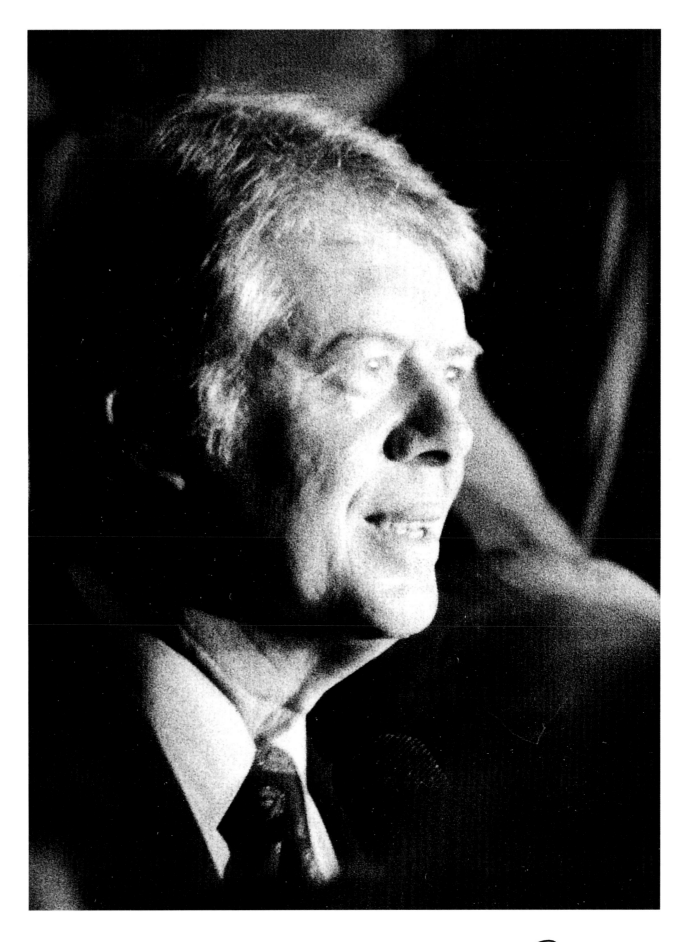

ELIZABETH TAYLOR

Elizabeth III : Never a child, always a queen.

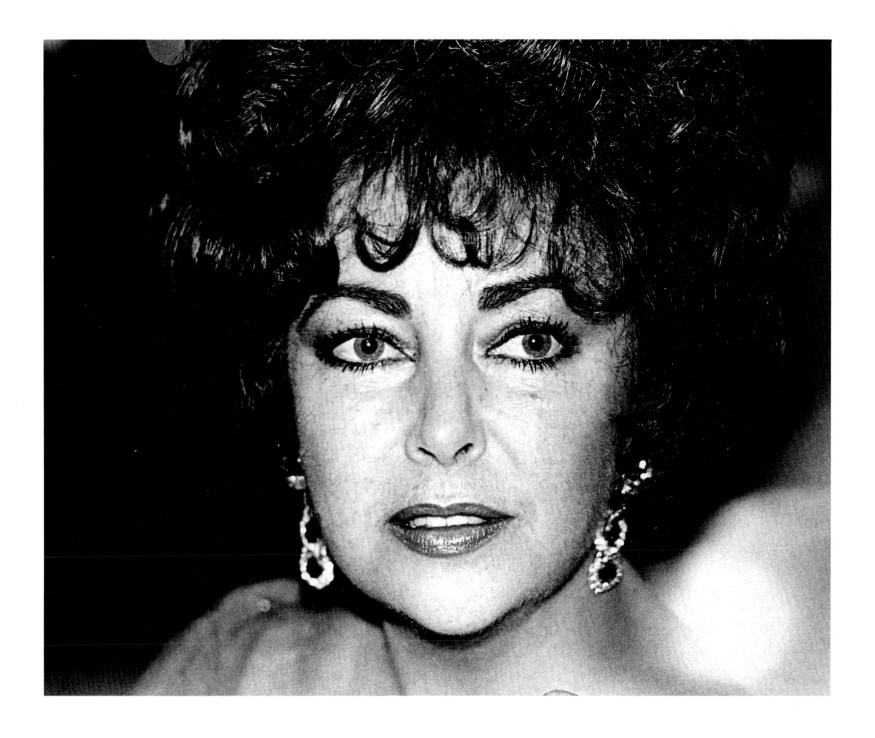

Moll Flanders with a screenplay by Gore Vidal.

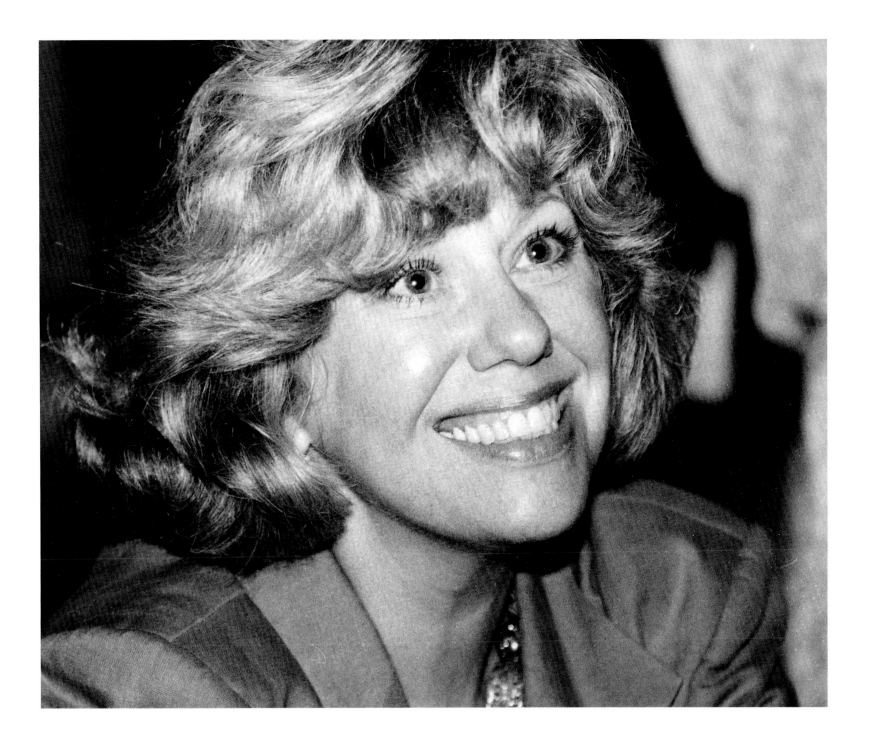

FERNANDO BUJONES

He has opened a new dimension in ballet
with this thrusting dagger legs and his royal sense of grace.

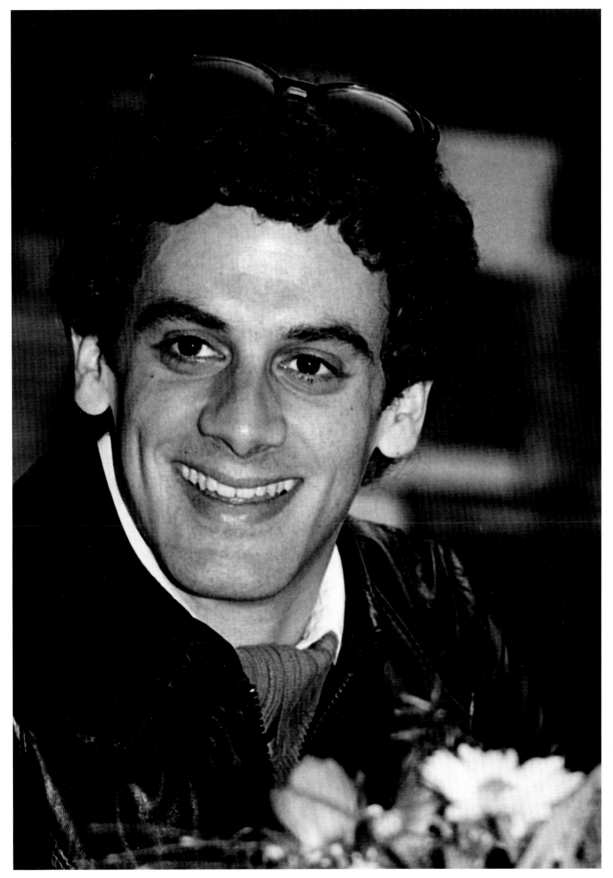

Fernando
Bufonts

FIDEL CASTRO RUZ

A bull. Brave, stubborn, doomed and tragically unconventional.

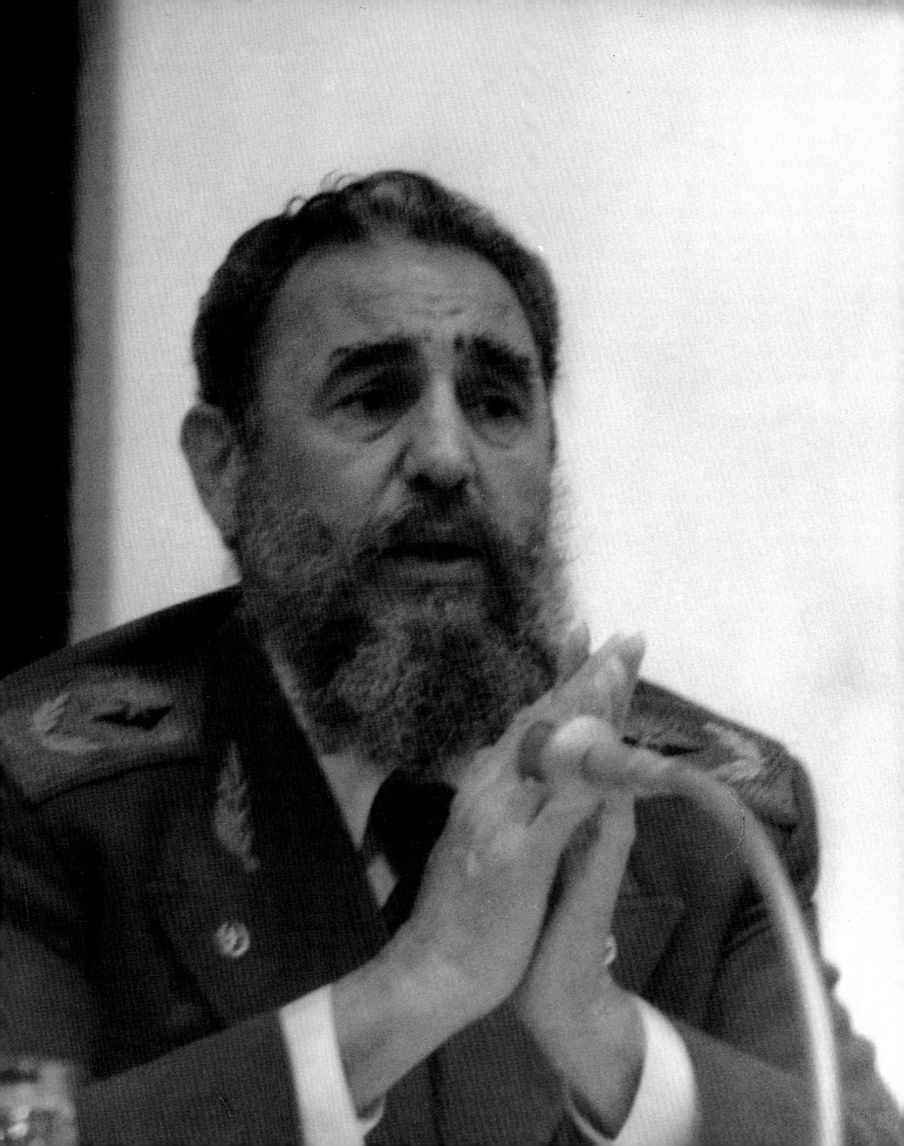

INDIRA GANDHI

Rankin-Smith wasn't allowed within fifty feet of her.
Her assassin got a closer shot.

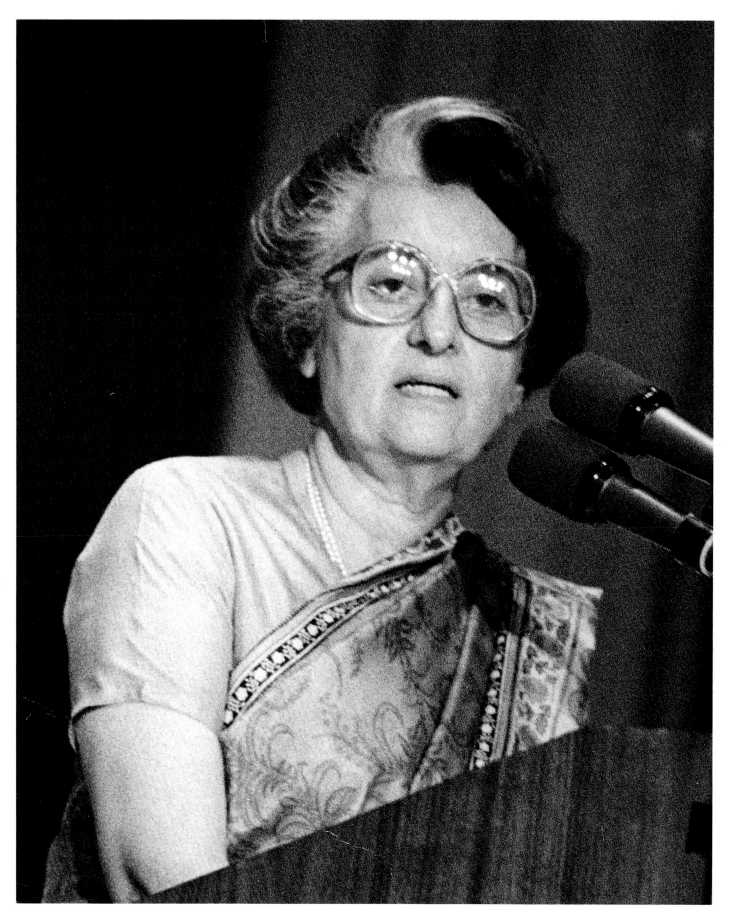

How dared he look like this in his eighties?

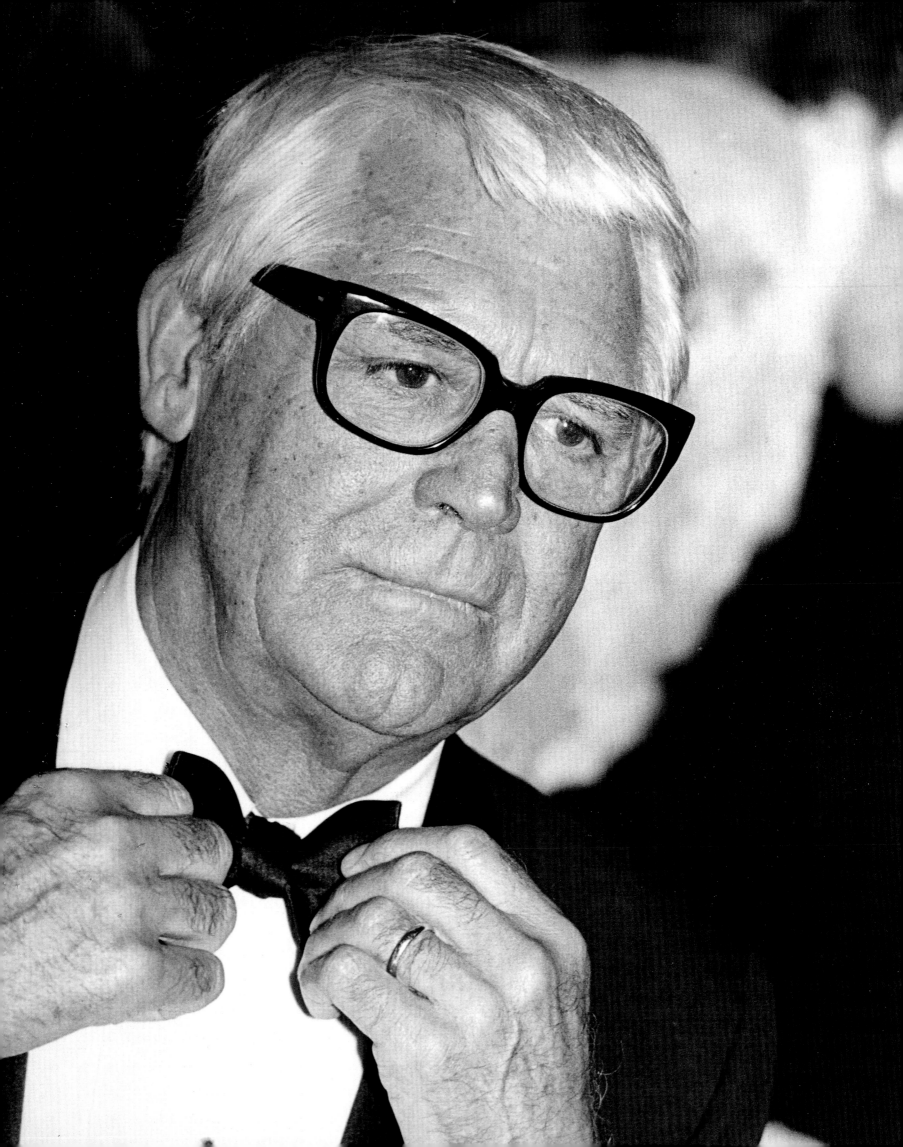

JOAN DIDION

Brain surgery with a gleaming stiletto and kid gloves.

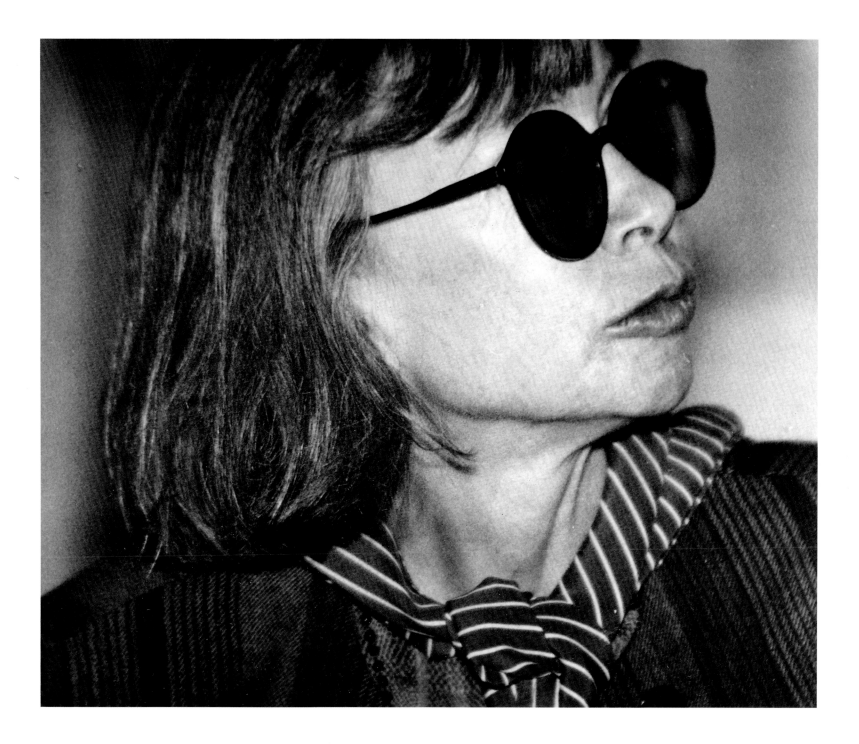

GEORGE BALANCHINE

The North Star. The Master.

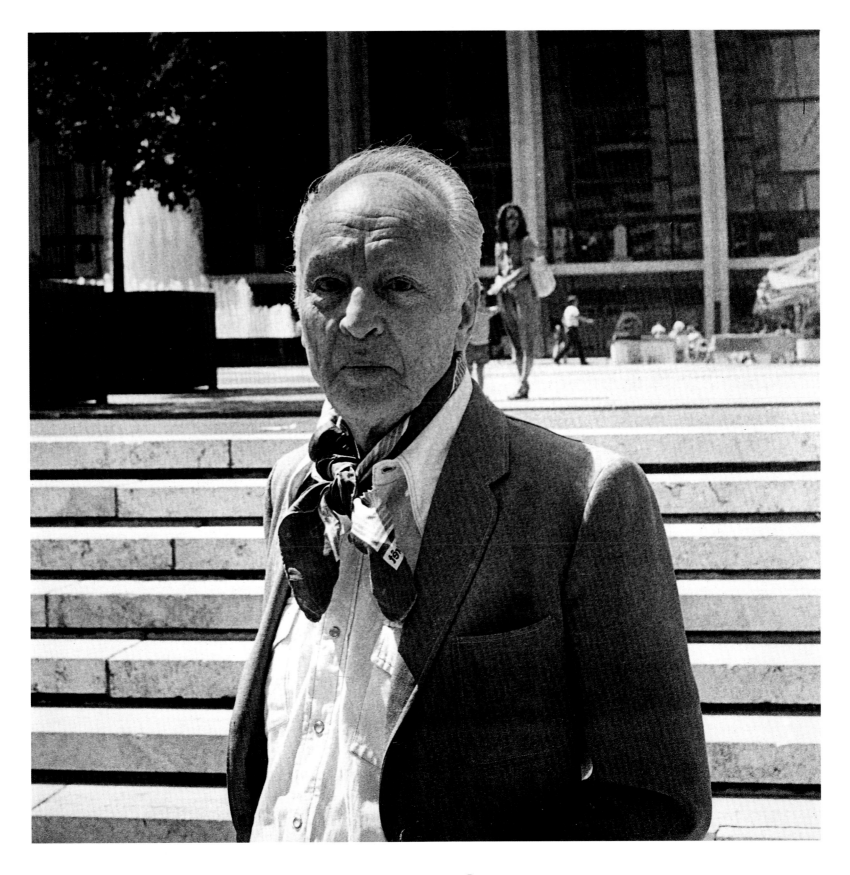

Only Rankin-Smith advancing on him could prompt General Patton to counter-attack with such a smile.

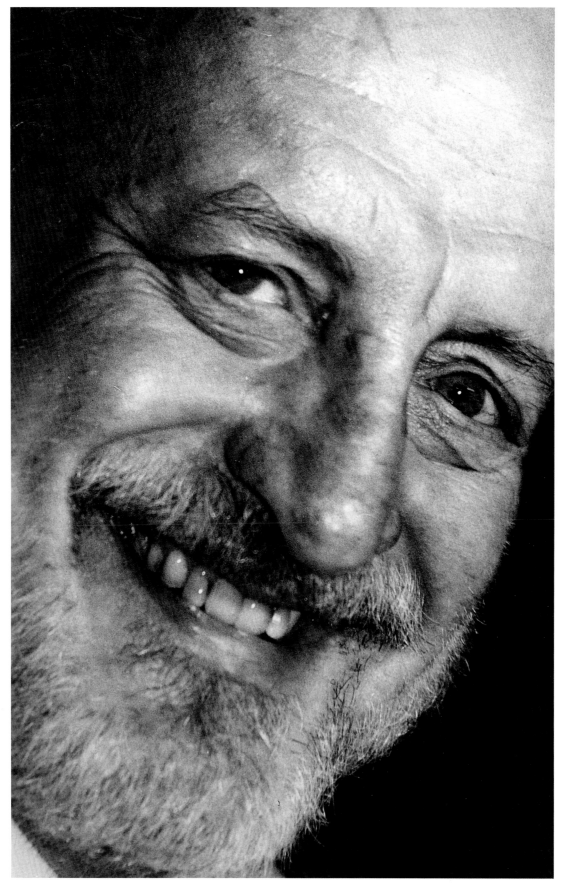

GEORGE SEGAL

Rumpled, gentle and sober, he haunts us with his plastered creatures inhabiting all the familiar places around us.

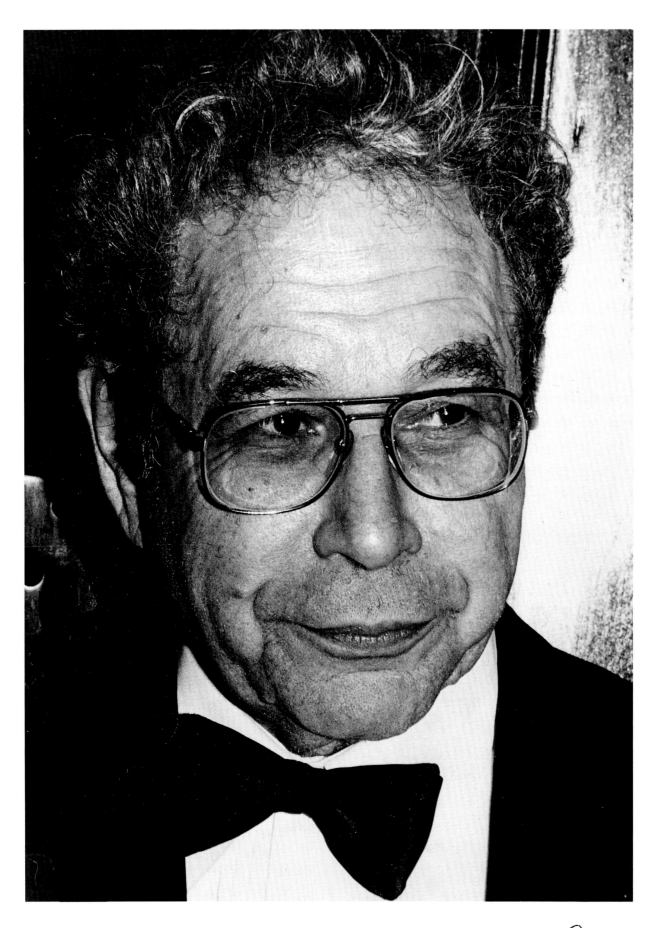

George Segal

GINGER ROGERS

Still twinkling at this late date.

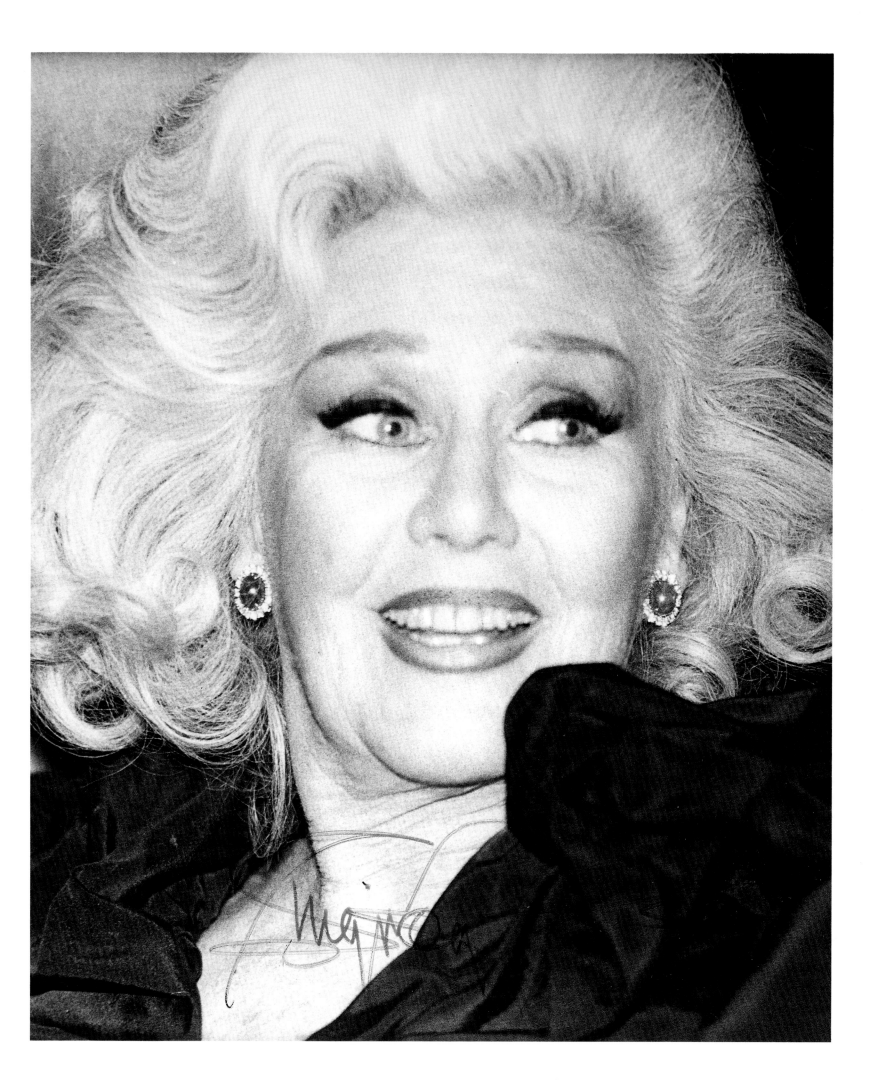

GLENOA JACKSON

Composed, intelligent, her aim is sure and high.
Perhaps, one day the prime minister?

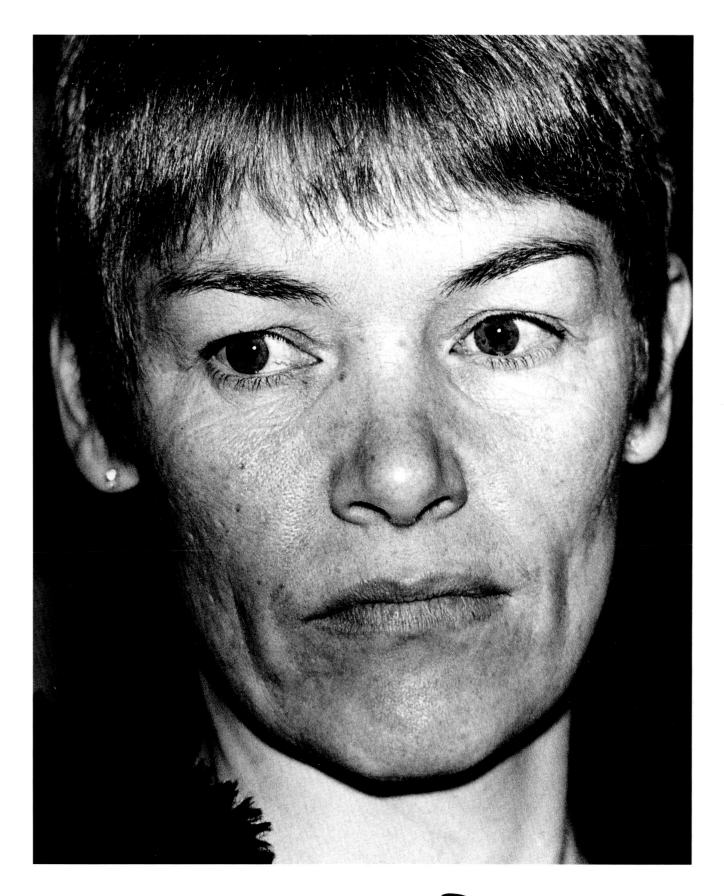

GLORIA SWANSON

They certainly did have faces in those days and
she kept hers till the glamourous end.

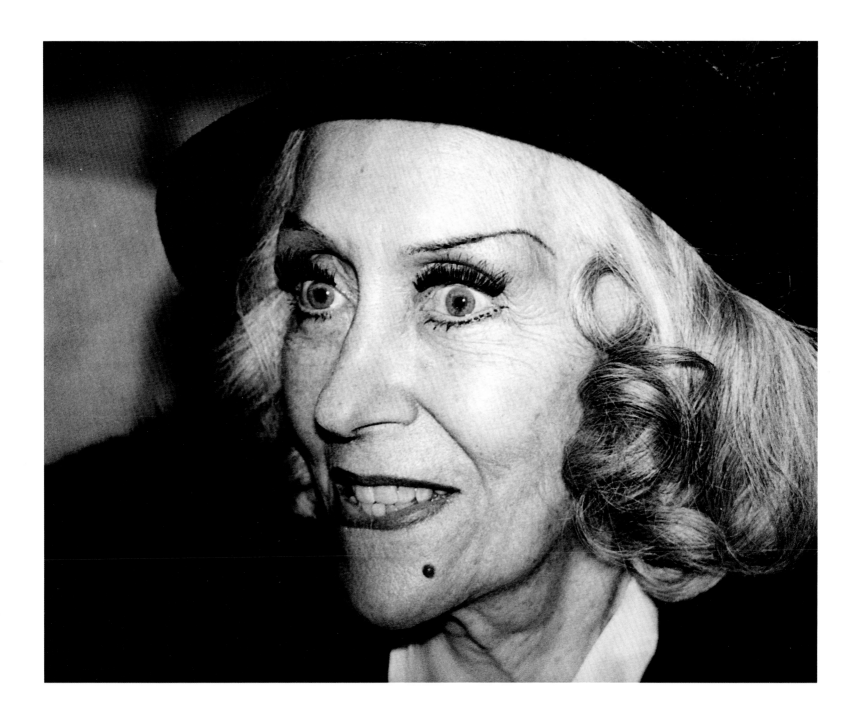

Gloria Swanson

GREGORY HINES

Quiet, still — the cellophane man — until his remarkable talent is on tap.

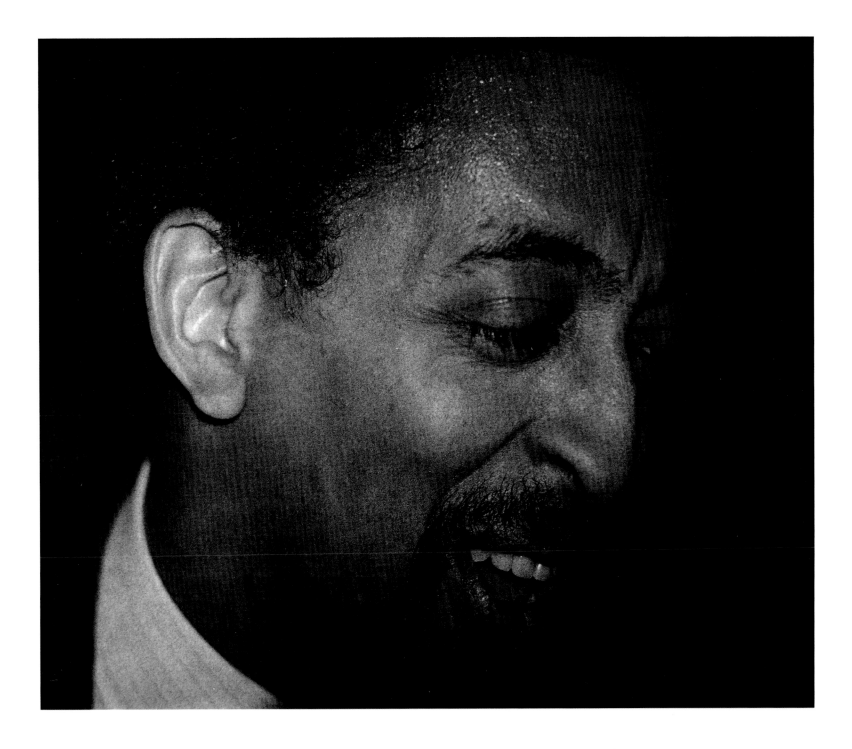

GREGORY PECK

Hollywood's really perfect and proper choice for
president of the United States.

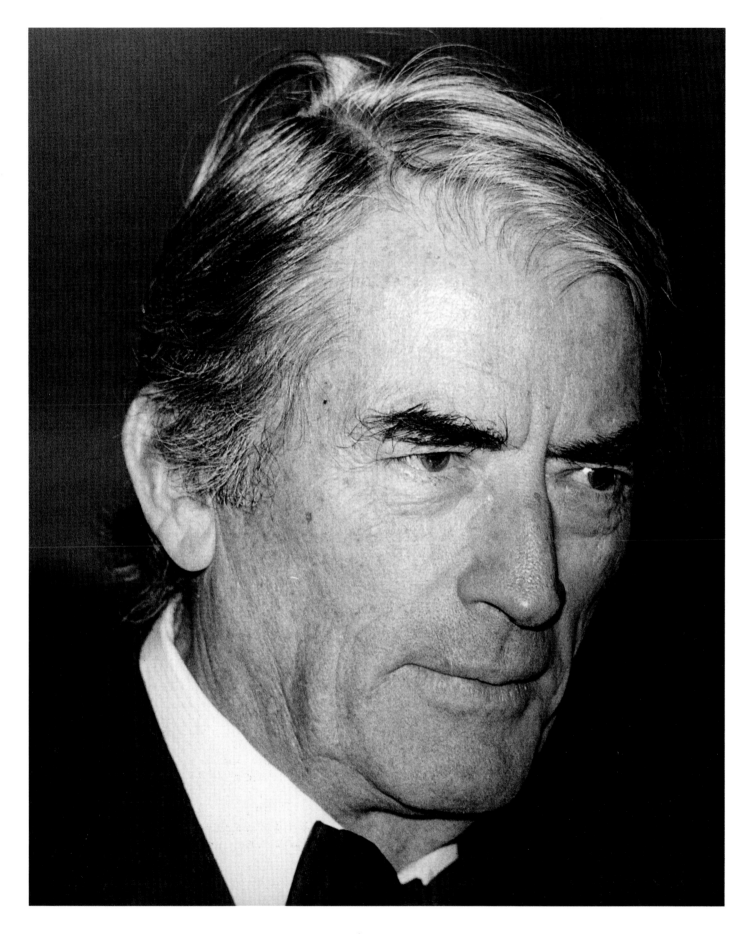

HELEN HAYES

This century's grand dame thespian.
I miss you lovely lady.

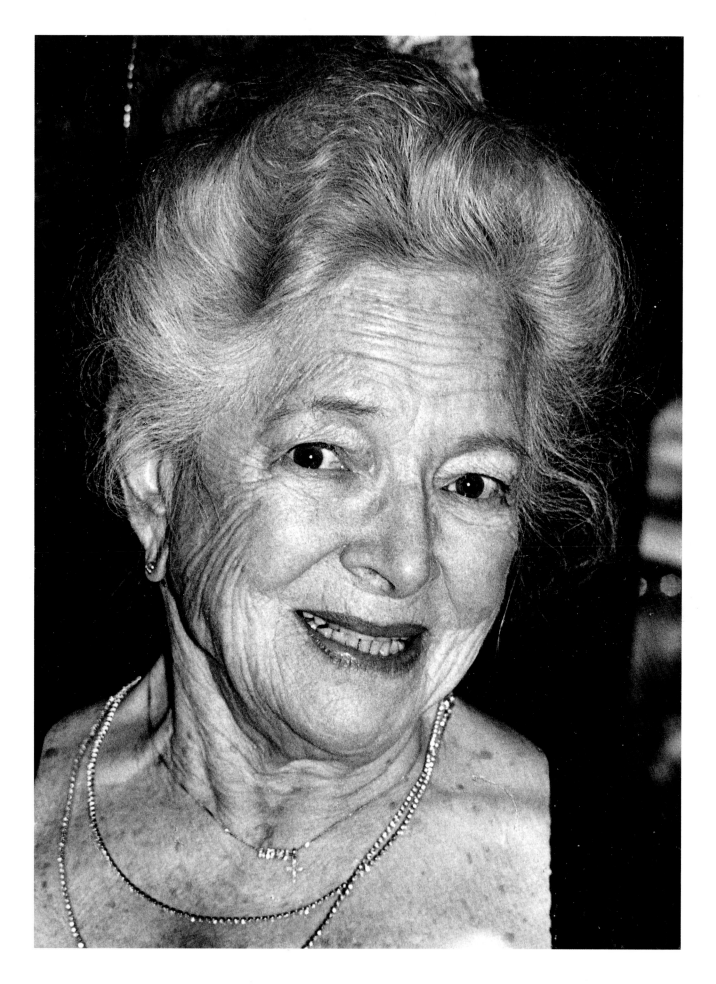

Helen Hayes

hENRY kISSINGER

Prince Metternich with a green card and teutonic dreams.

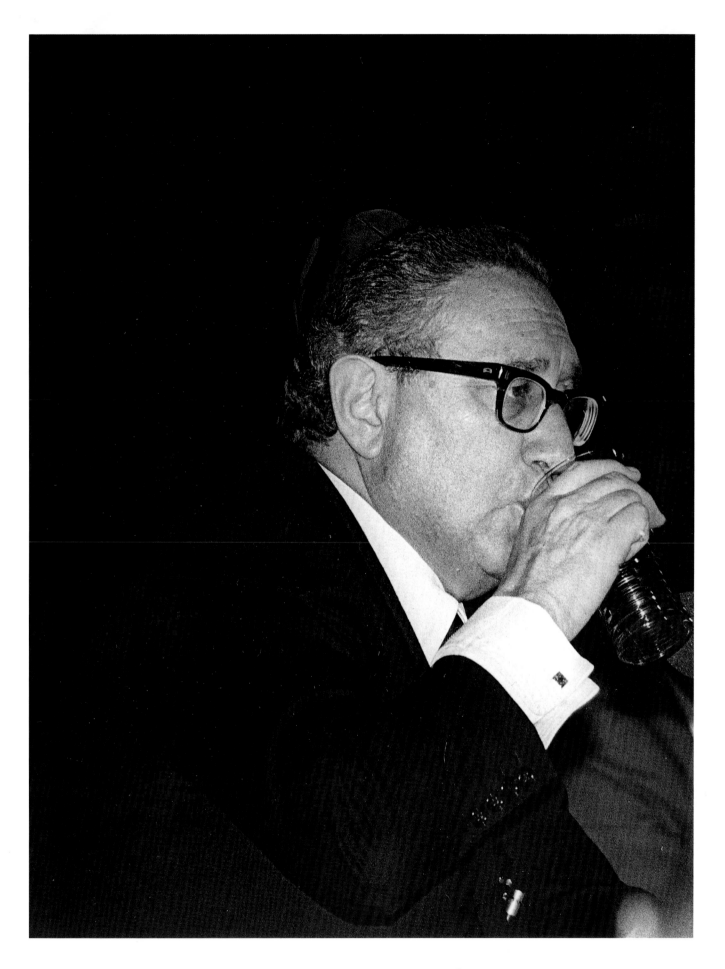

I. M. PEI

A genius whose architectural geometry has made Washington, Paris and Hong Kong ports of call for the Starship Enterprise.

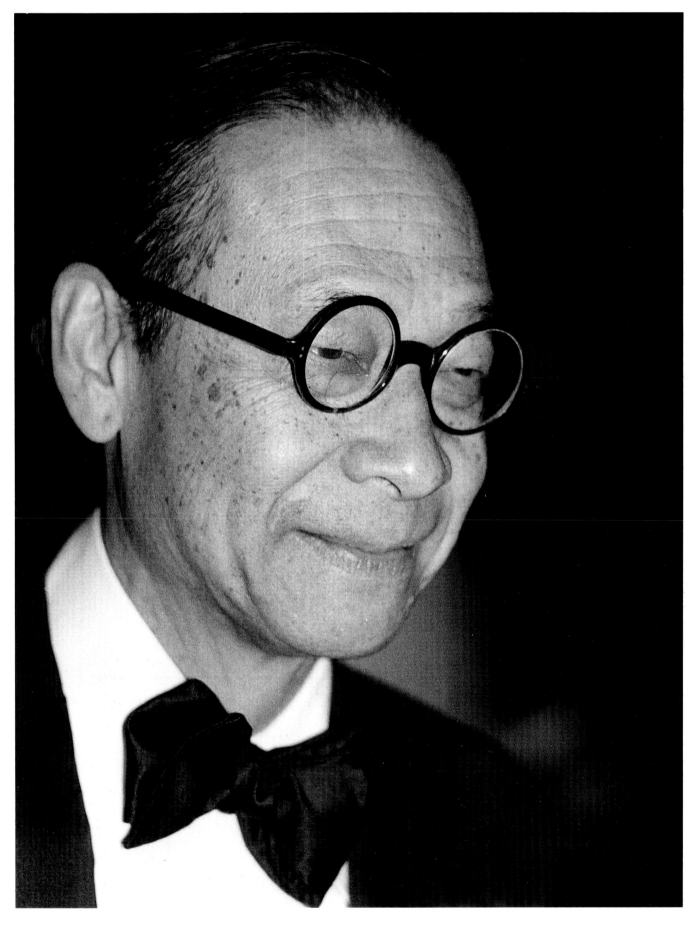

JACQUELINE KENNEDY ONASSIS

Vulnerable yet filagreed steel. Hounded but above the fray. And
'neath it all a Botticelli finished by Miss Porter.

Jacqueline Kennedy Onassis

JACQUES D'AMBOISE

Balanchine's "danseur noble" and everyone's Prince Charming.

Jacques d'Amboise

JAMES BALDWIN

Elegant fury and lyrical scorn etched in black and white.

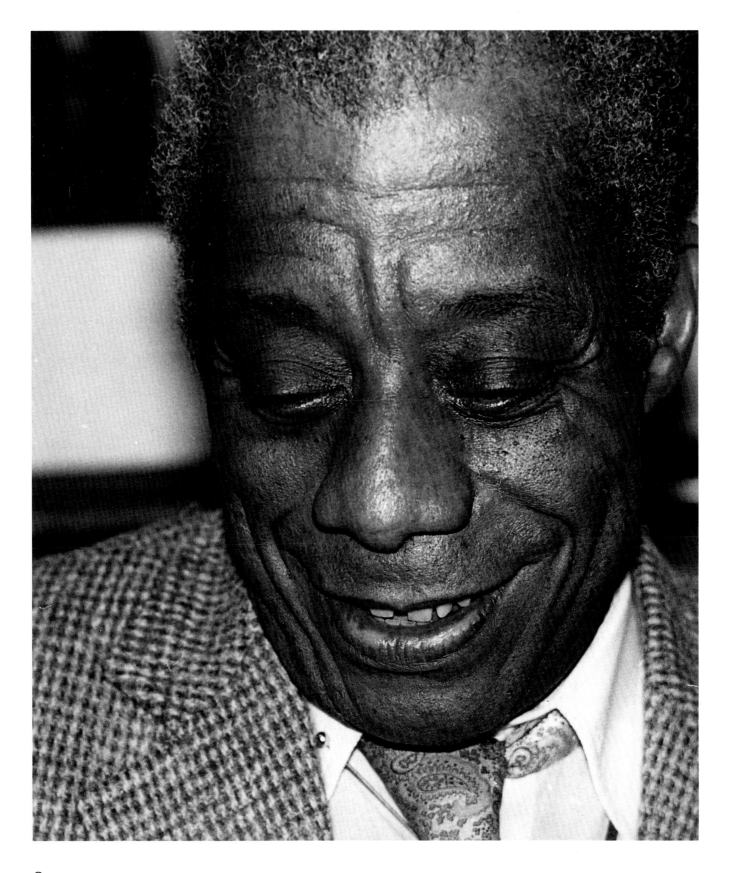

Peace.

James Baldwin.

JAMES STEWART

The last remaining star in his silvery galaxy.

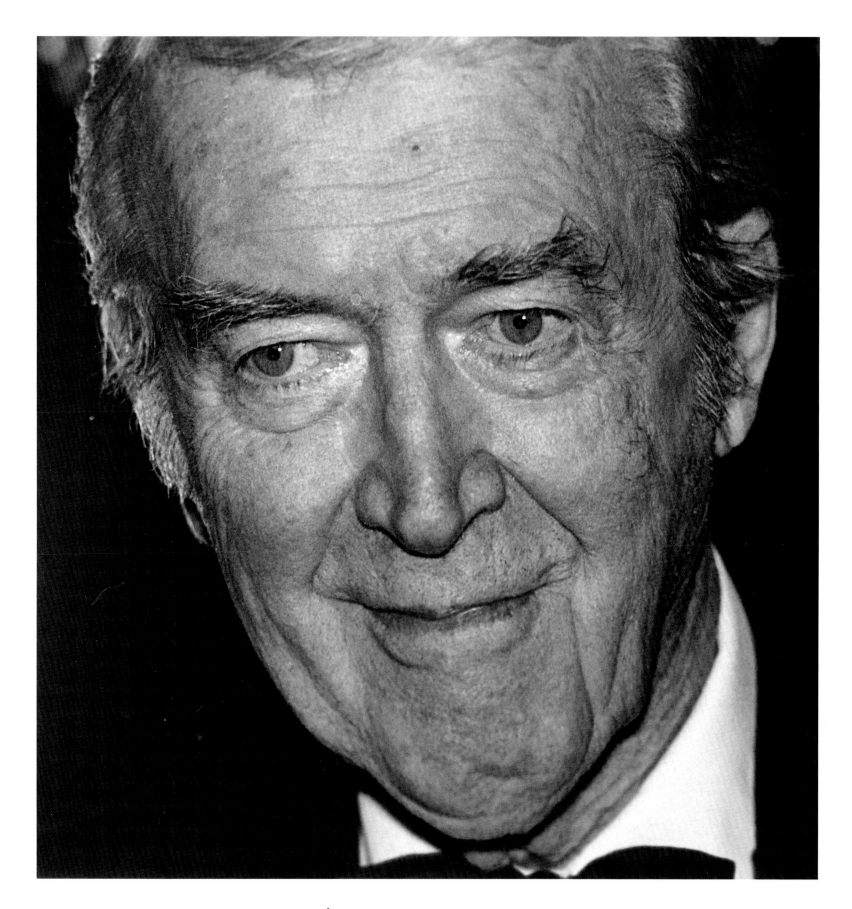

James Stewart

JERZY KOZINSKI

Franz Kafka in a more felicitous mood.

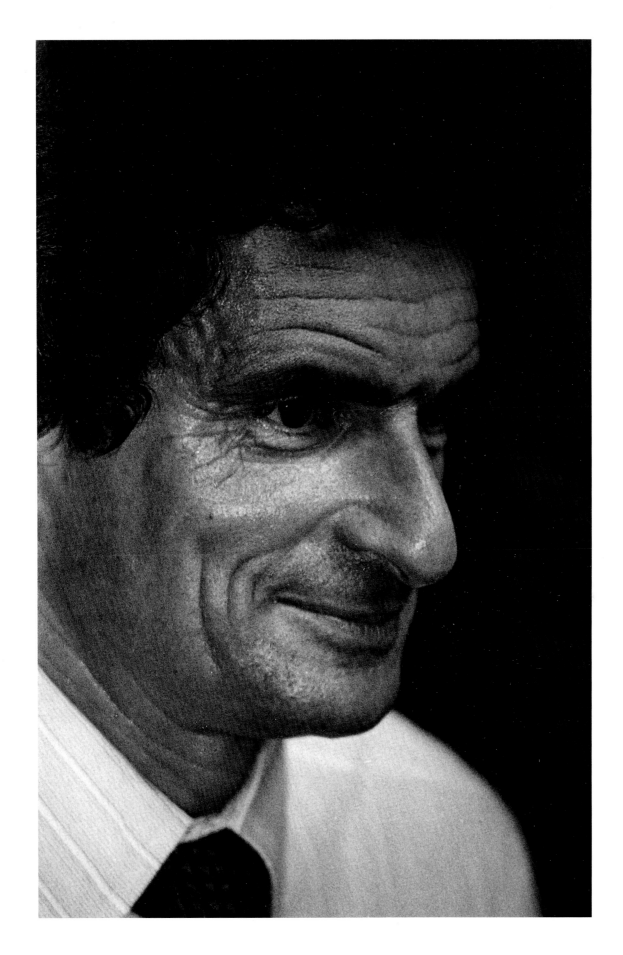

JOHN IRVING

Handsome is as handsome does — and he did.

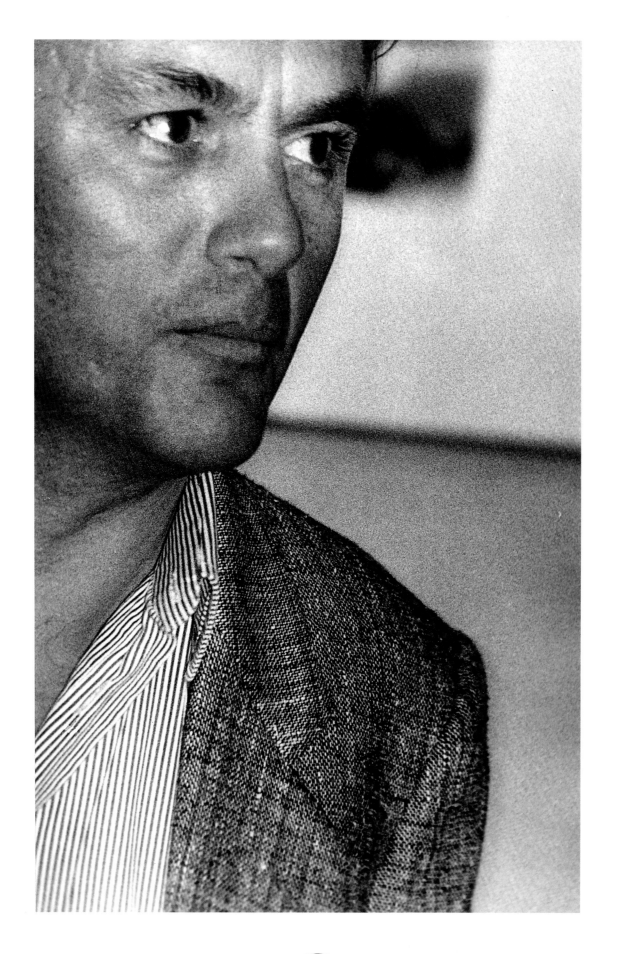

JOHN UPDIKE

Sir Peter Rabbit himself. Rankin-Smith gave him a palm frond.
He deserves a laurel wreath.

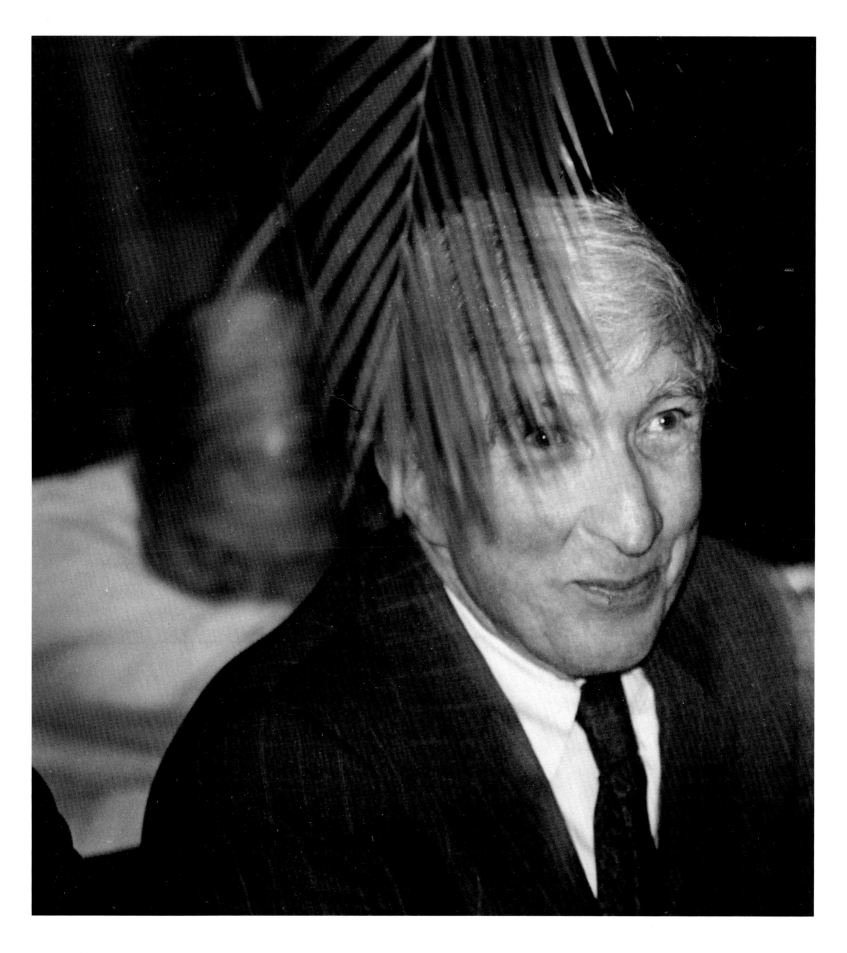

I guess this is me

John Updike

JOSE FERRER

Lago, Cyrano, Toulouse-Lautrec grown tall and
grizzled before he left us.

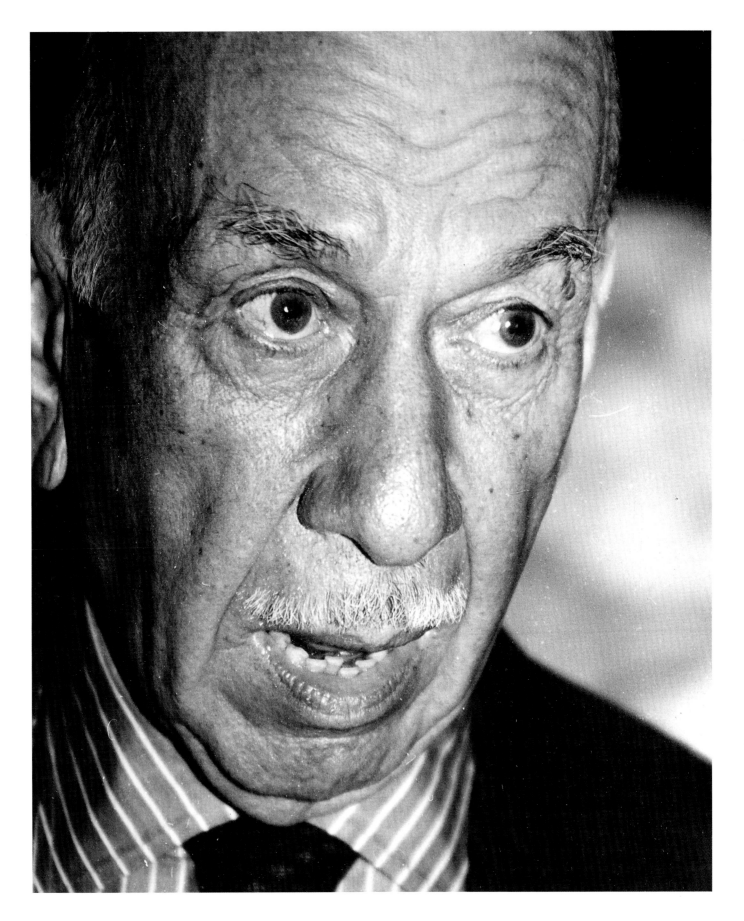

KURT VONNEGUT

Lewis Carroll through the looking glass darkly.

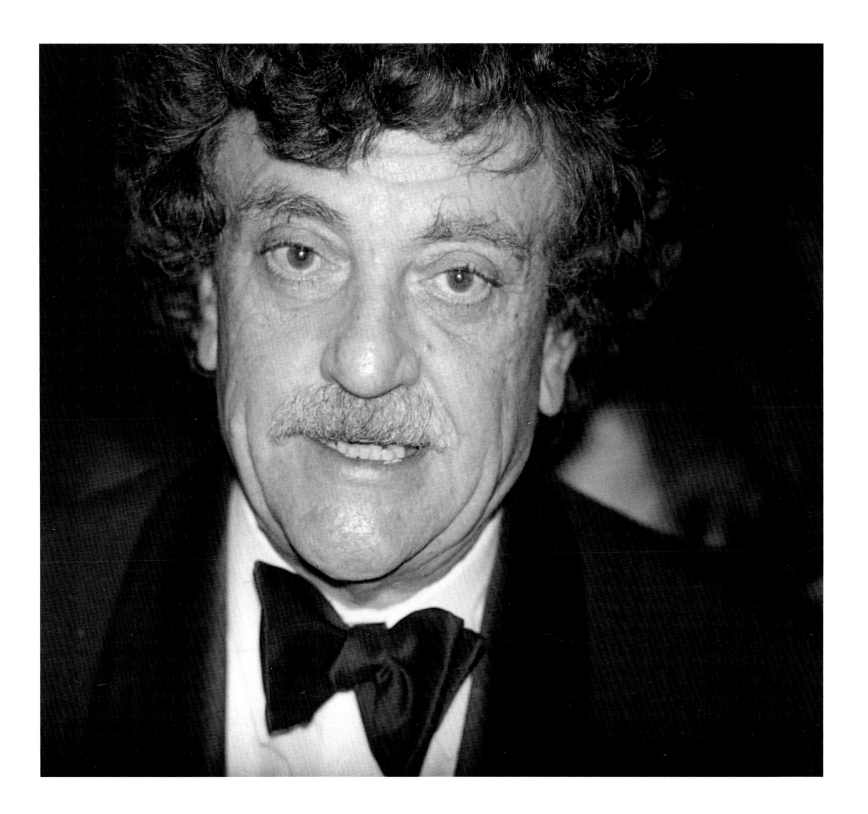

Lauren Bacall

A curl of smoke rising from a dozing Vesuvius.

Lauren Bacall

LIBERACE

Rings on his fingers. Bells on his toes. Derided, adored, ridiculed
and oblivious, he giggled all the way to the bank.

1983

LIV ULLMAN

A Bergman persona. Early morning sunlight streaming through the silver birches.

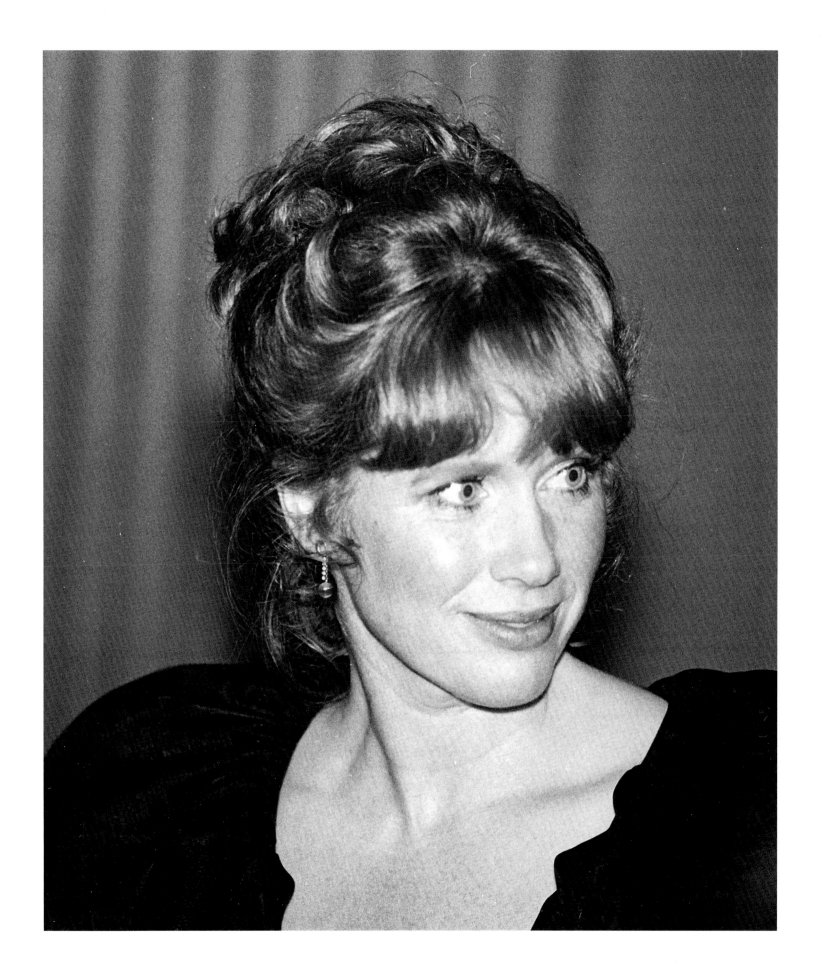

Louise Nevelson

A unicorn. Her sculpture sings like some skyscrapers do.
She was a sculpture, spare and gothic, and dressed to the teeth.

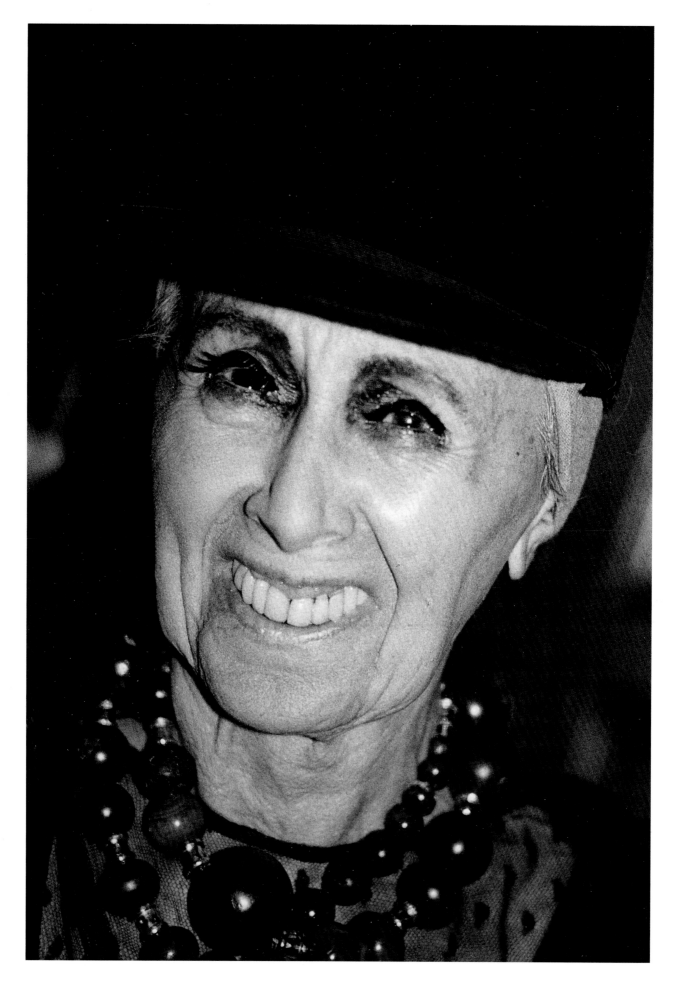

Louise nevelson

MikhAil BARyshNikov

The one and only Mischa and ours. He's become such a yank,
one expects him to answer to "Mike".

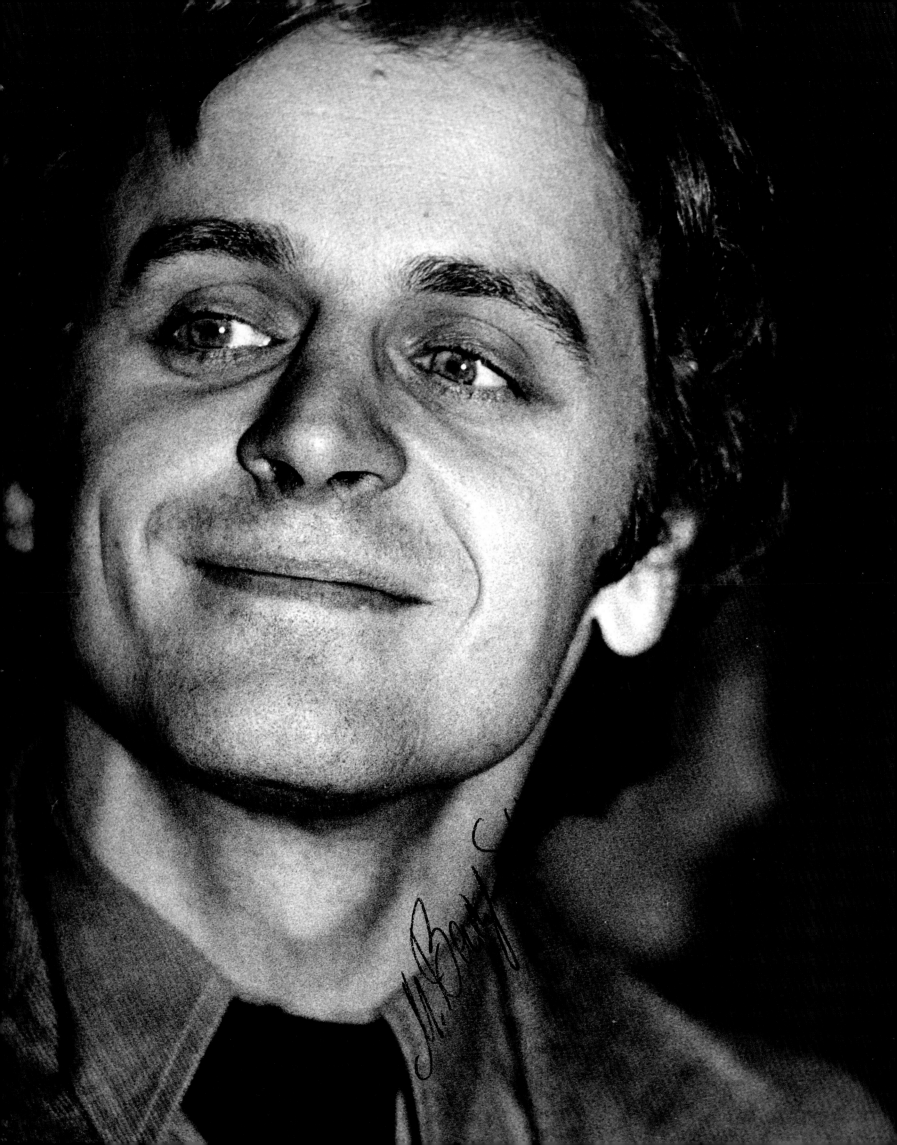

RUÓOLF NUREYEV

He made that fabulous leap across the ocean and conquered the west as Stalin and Kruschev and Co., with all their gravity, could not.

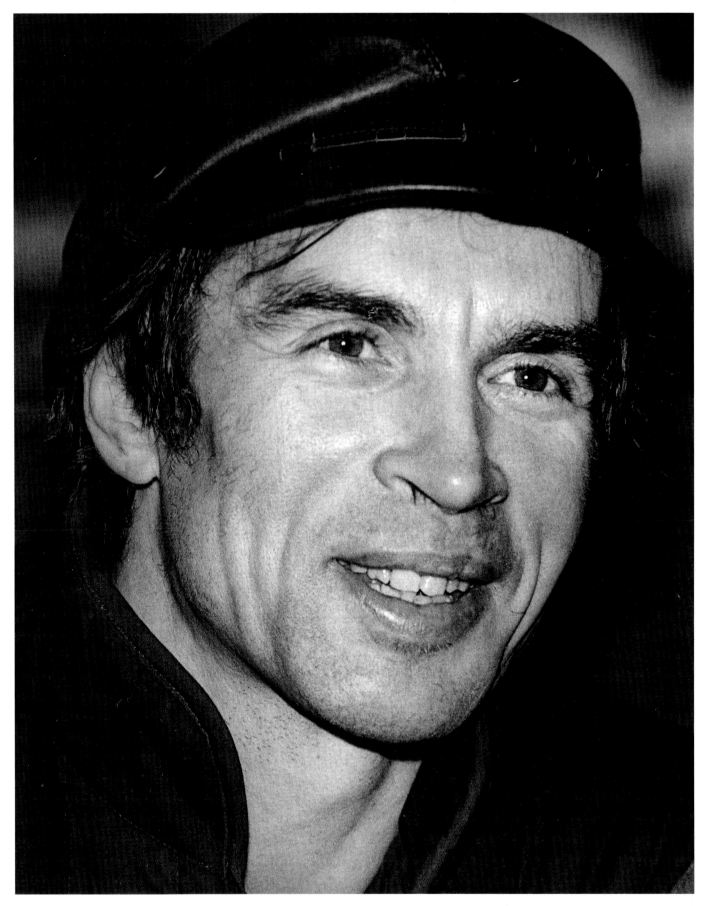

NORMAN MAILER

The elder statesman of letters. Mellowed, his only discernible blemish can vanish with a band-aid.

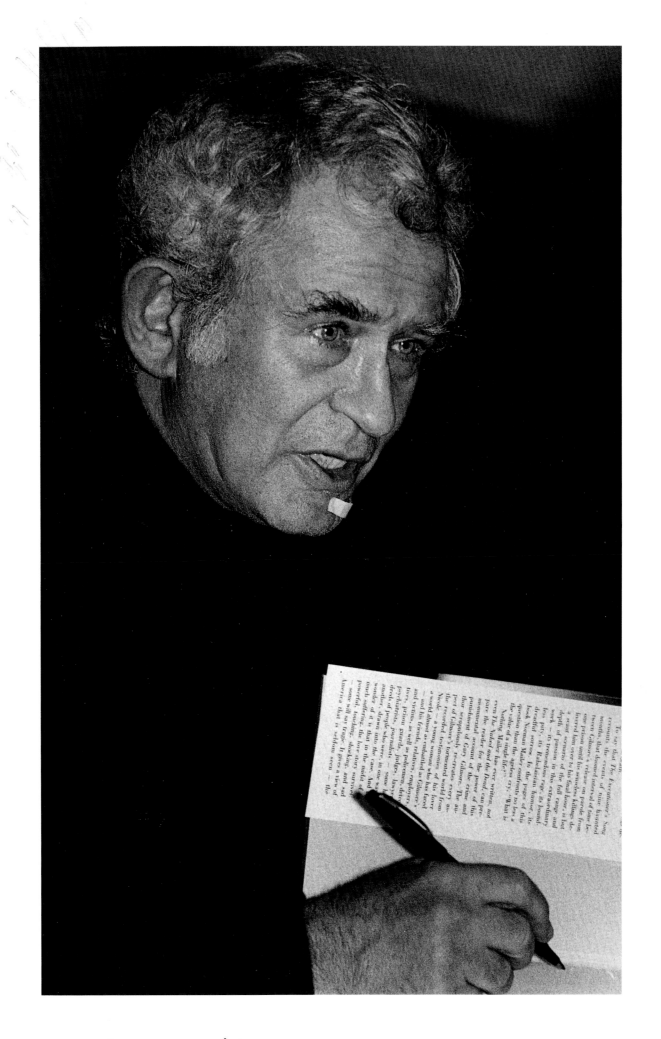

Norman Mailer

PATRICIA McBRIDE

A fragrance that danced by, lingering for a wondrous moment before it floated away.

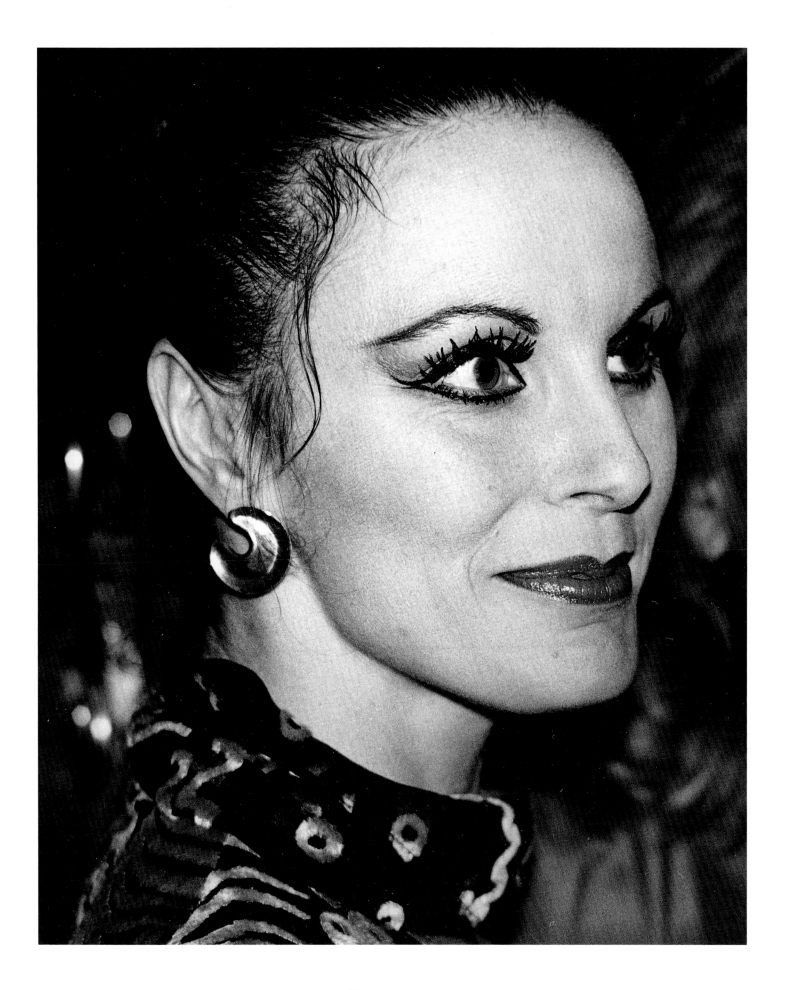

Patricia McBride

LUCIANO PAVAROTTI

A voice as close to perfection as humanly possible.

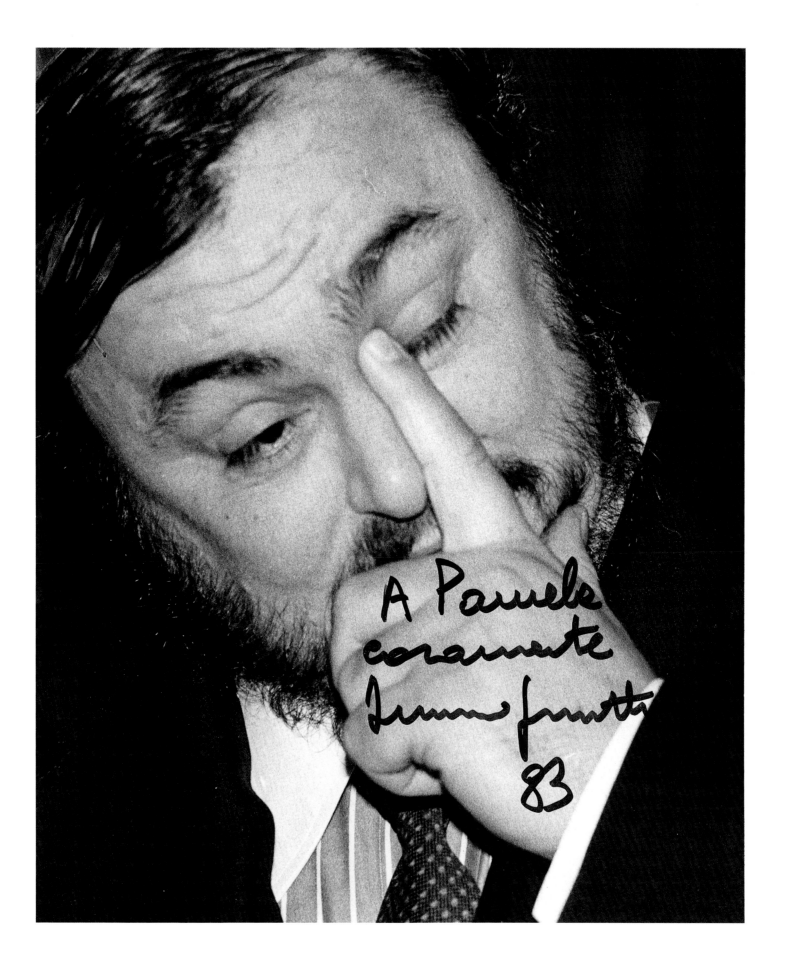

placido domingo

Well named. His sound can become light filtered through a cathedral window. One can believe more easily.

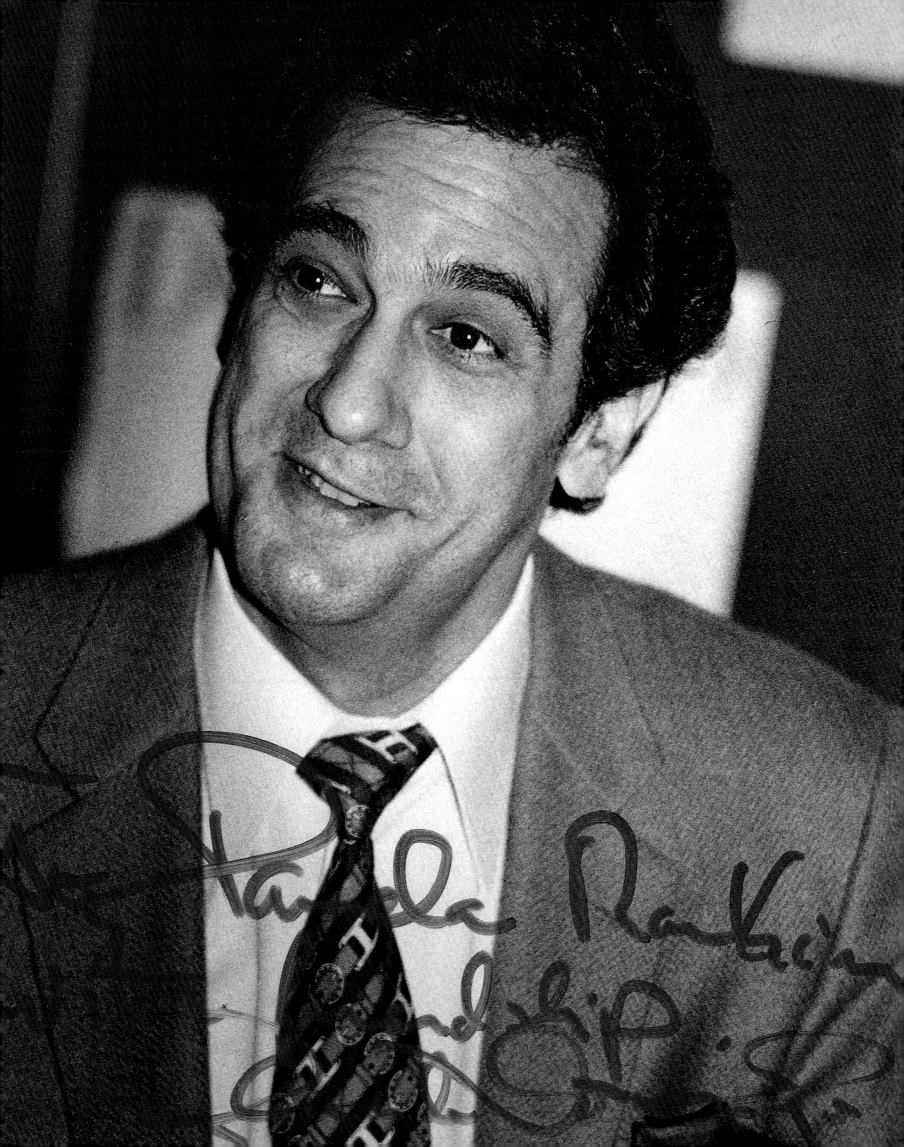

RAISA GORBACHEV

The last first lady of the Soviet Union.
We haven't seen the last of her Gorby. Not nyet.

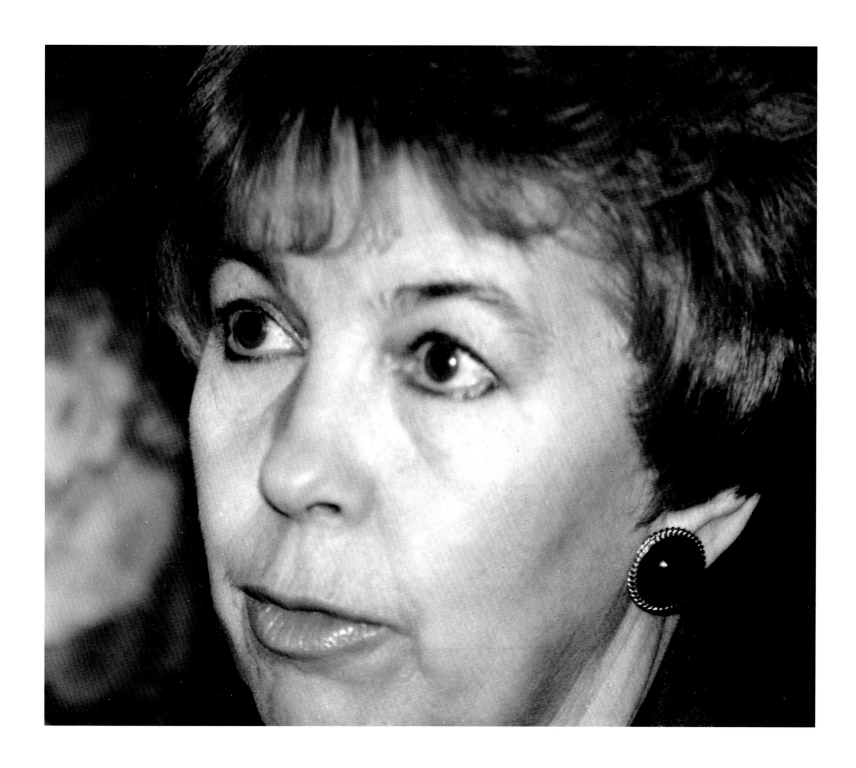

RICHARD BURTON

While he and the Mrs. were wrecking Noel Coward's and
their own private lives.

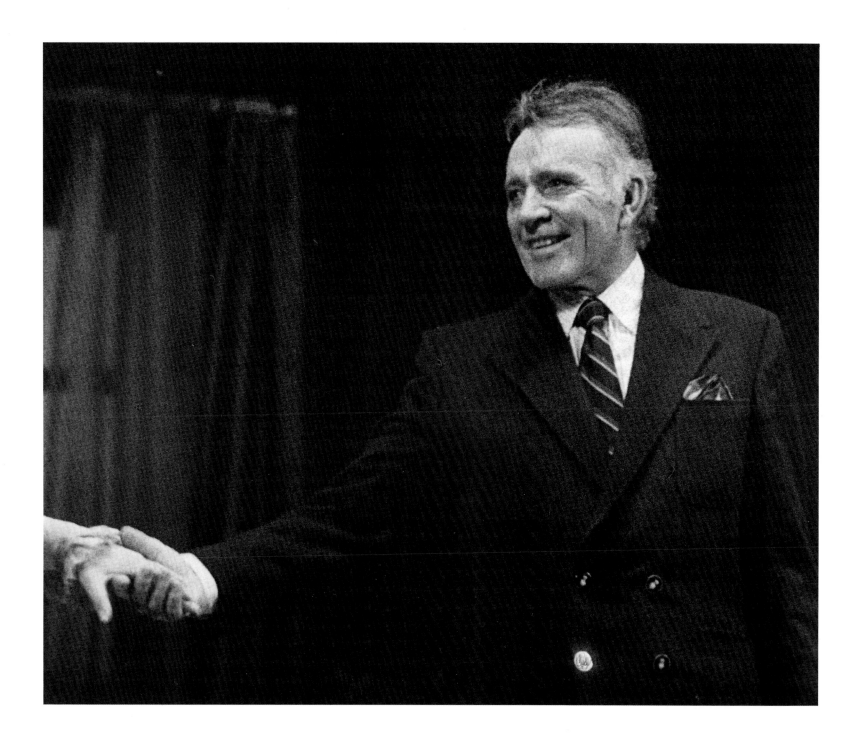

Richard Burton

ROBERT RAUSCHENBERG

Full of laughter, invention and aqua vitae.

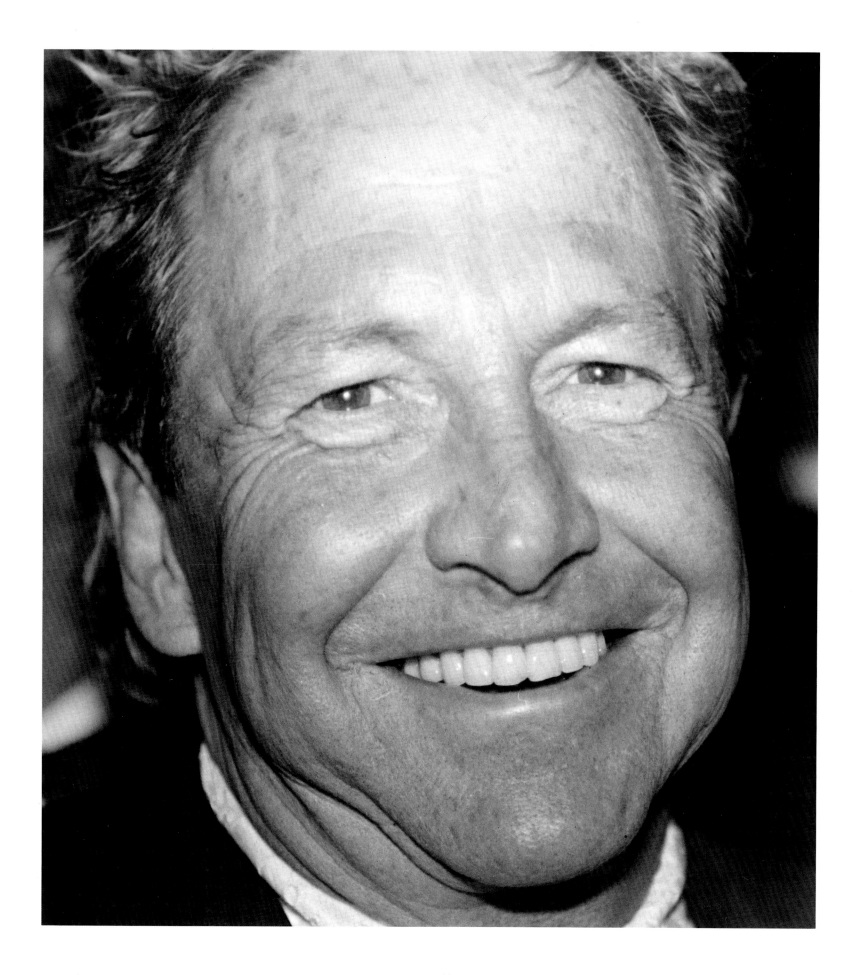

BOB RAUSCHENBERG

ROY LICHTENSTEIN

A demure and courteous man with a bubble over his head that screams:
"Bang! Wham! Help!"

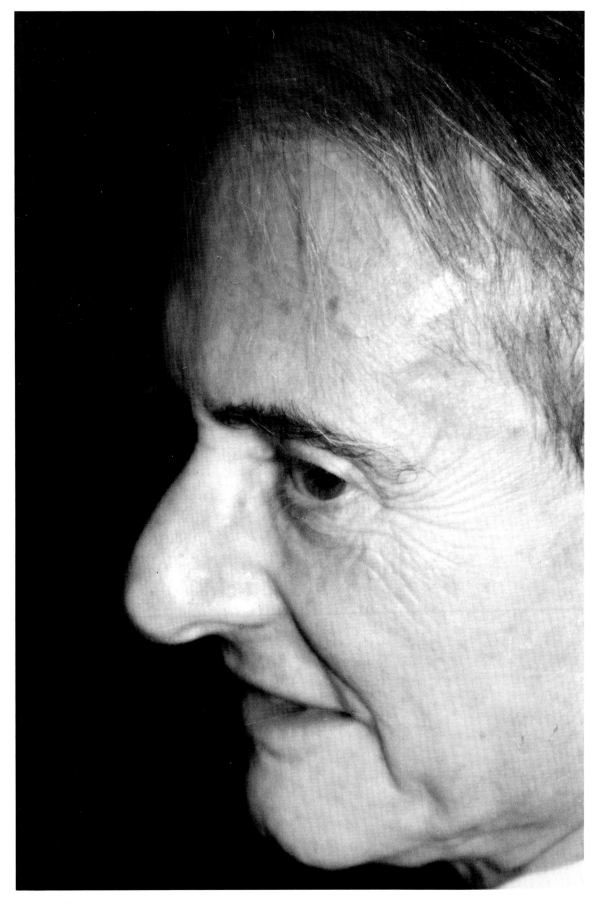

ANWAR EL SADAT

A hero who cut the Gordian Knot and was cut down for it.
His star is nailed to the heavens.

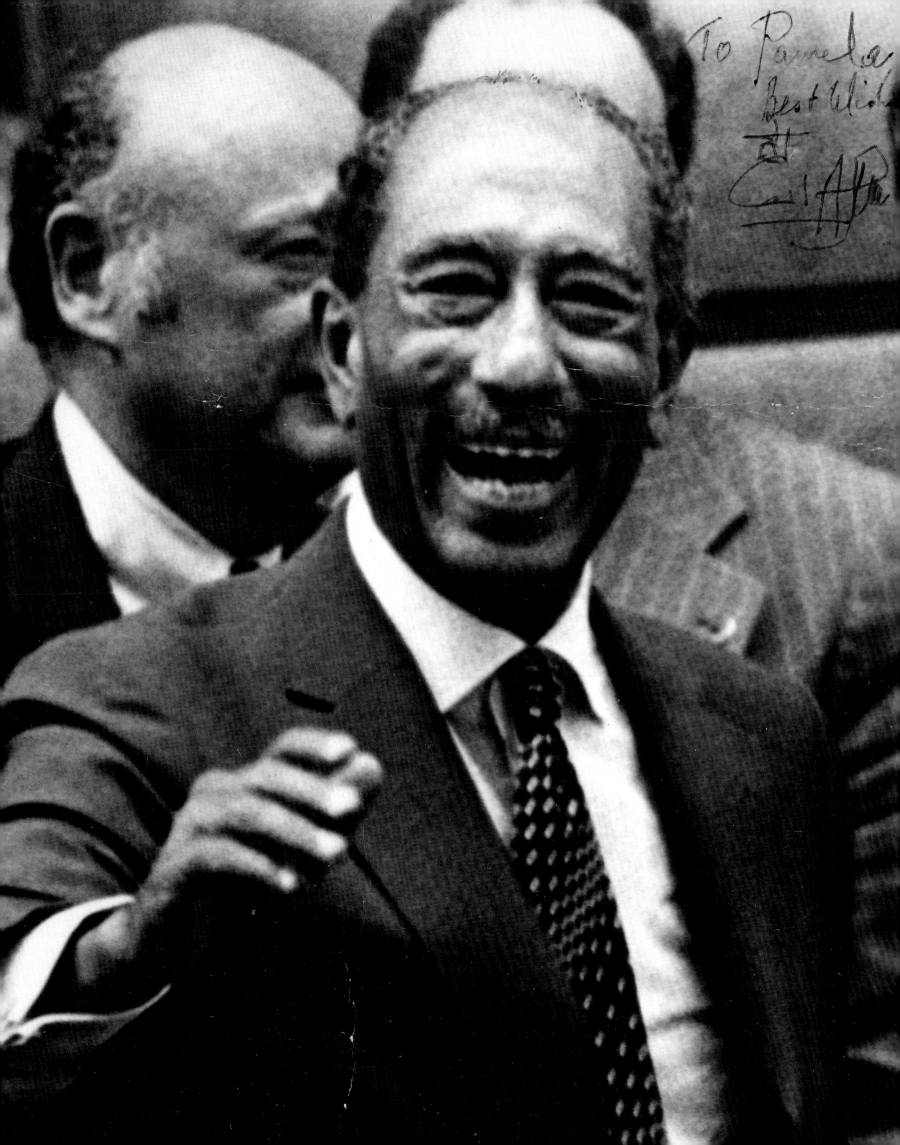

To Pamela
Best Wishes

SAMMY DAVIS, JR.

It was serious and killing business being Mr. Wonderful.

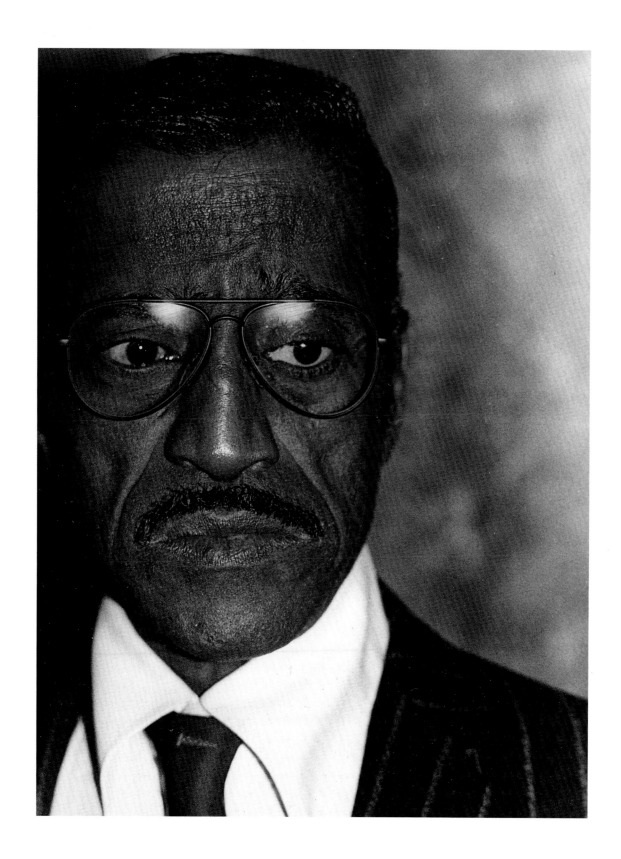

seija ozawa

Yes! Yes! It's true that he took over the Boston Orchestra but we're all thrilled about it.

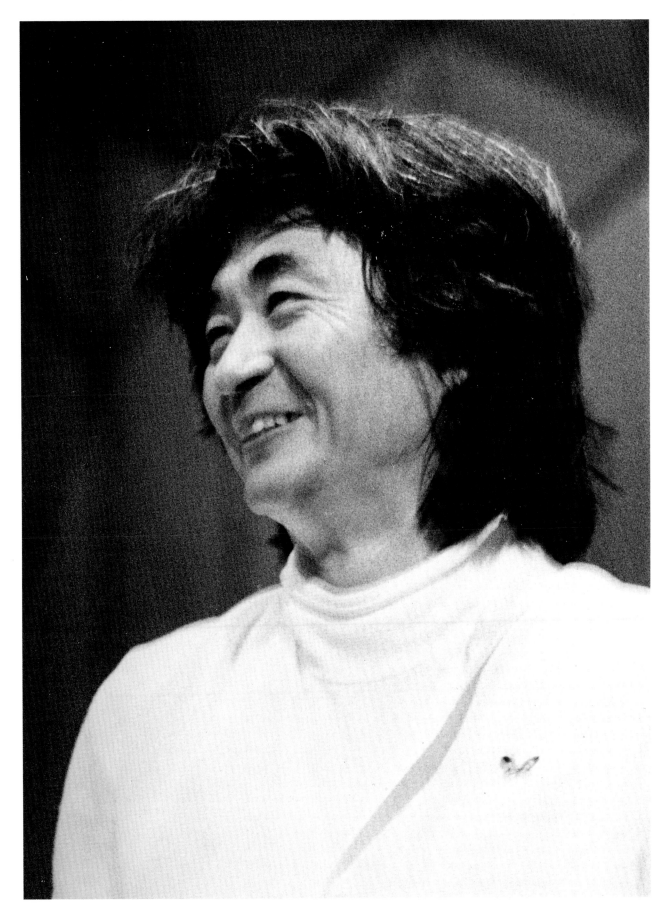

If anybody sees this man, please contact Spielberg or Altman immediately.

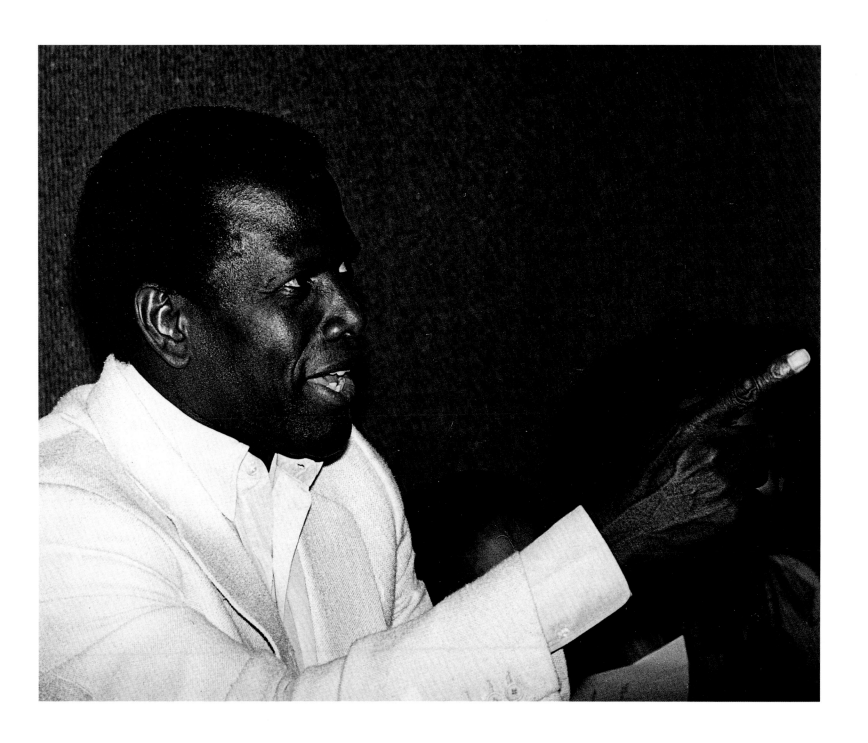

Happiness
alway
Sidney Poitier

sissy spacek

A translucent Vermeer maiden catching the light through a leaded window.

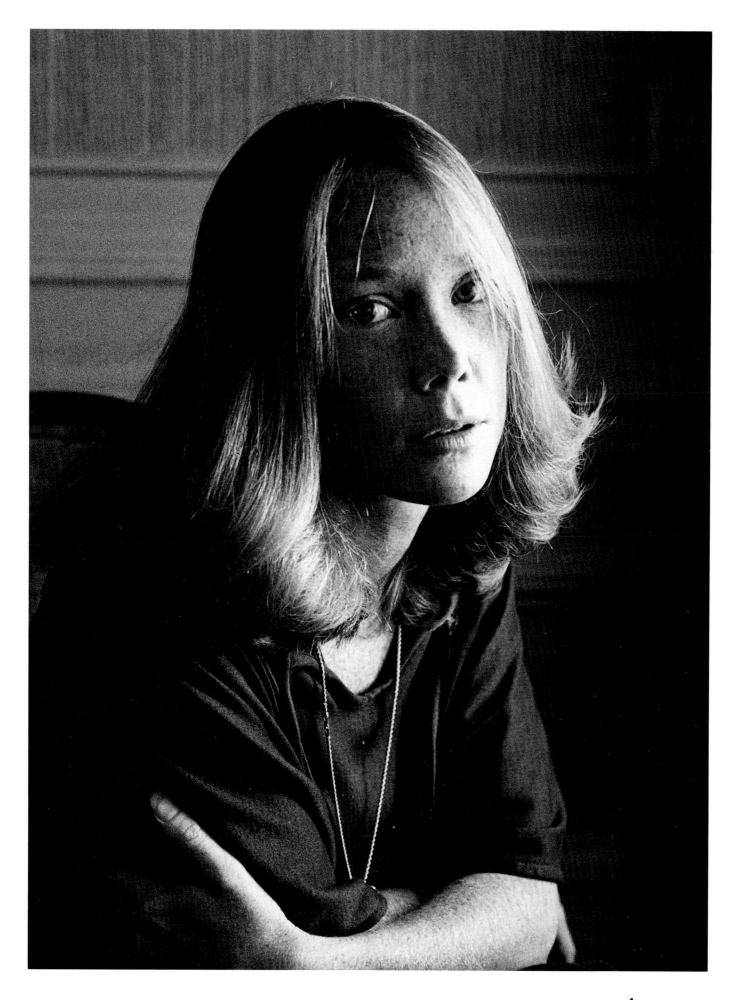

Sissy Spacek

SUSAN SONTAG

The exquisitely precise workings of a Swiss movement.

Susan Sontag

TRUMAN CAPOTE

Curiouser and curiouser, from "enfant" to ancien "terrible",
he became wickeder and wickeder and then just blew away.

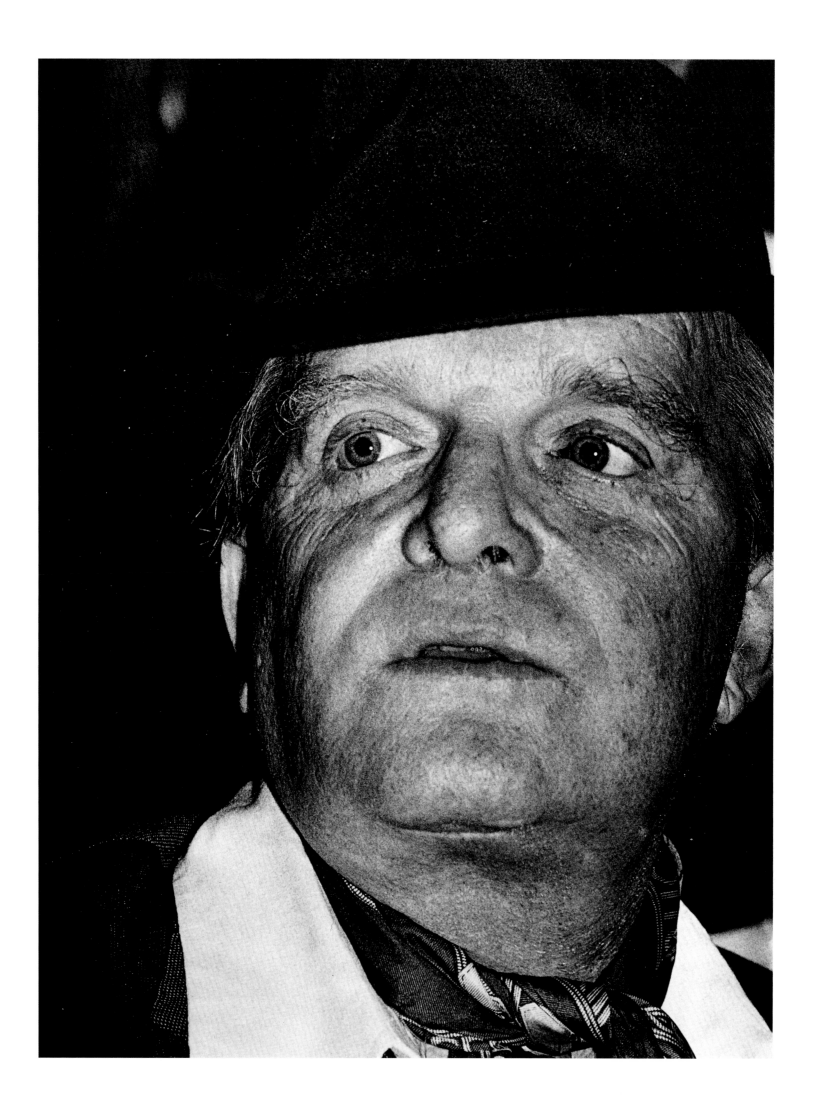

VICTOR BORGE

He can make a dreaded audit at the IRS into a delightful diversion.
He's been touched by the wand.

VLADIMIR HOROWITZ

Ivory and pure gold. A triumph of madness over method.
He delightedly autographed this photograph and started a trend.

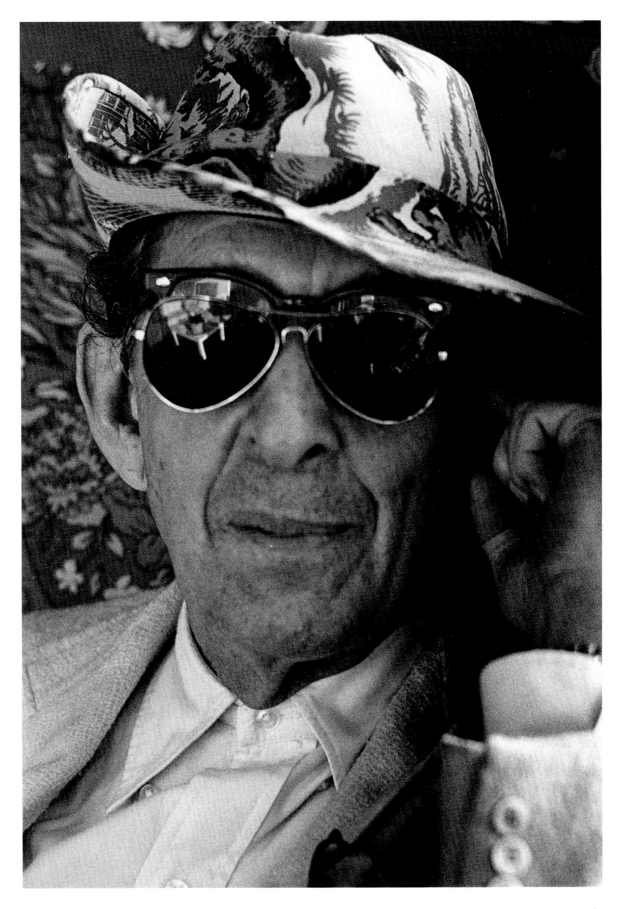

ZUBIN MEHTA

A conductor of electricity, heat and beauty.

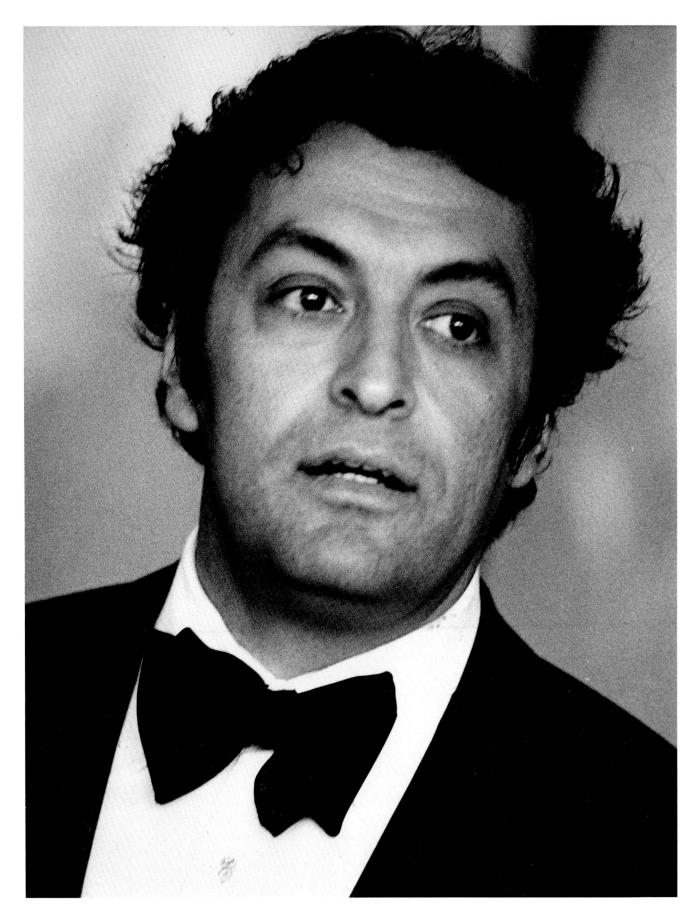

AL HIRSCHFELD

A child's image of the Old Testament God — only nicer.

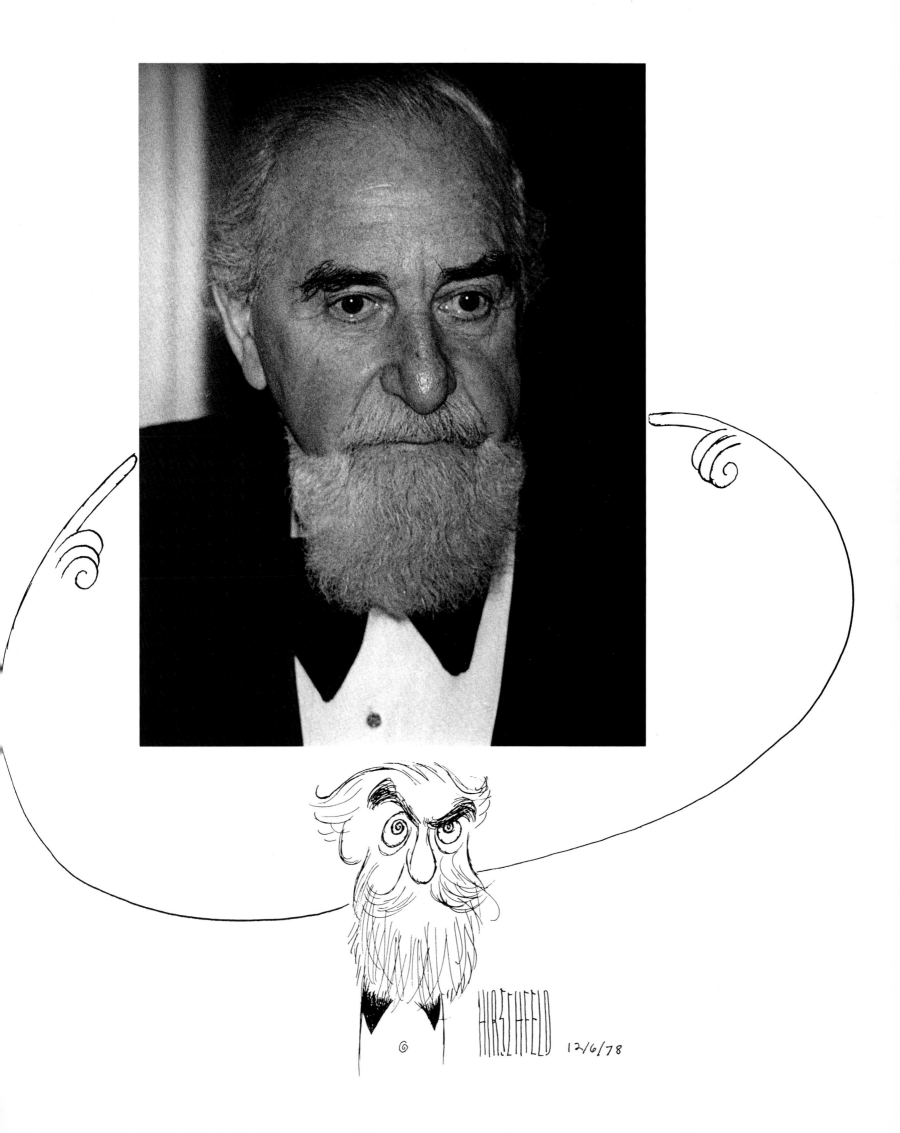

RUSSELL BAKER

The funniest thinker at the gates of hell. Rodin's.
With an unseen and wry smile and a martini on the rocks.

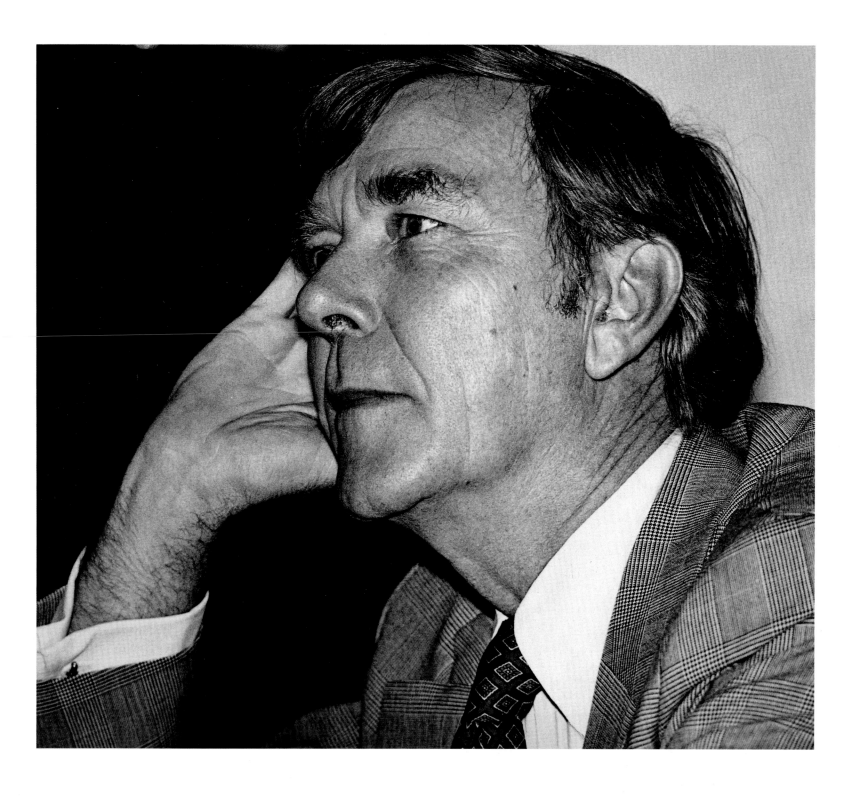

"Why can't I listen to Mahler without getting this overpowering urge for a hot pastrami on rye?"

Russell Baker

VARTAN GREGORIAN

The lion that really guarded and saved The New York Public Library.

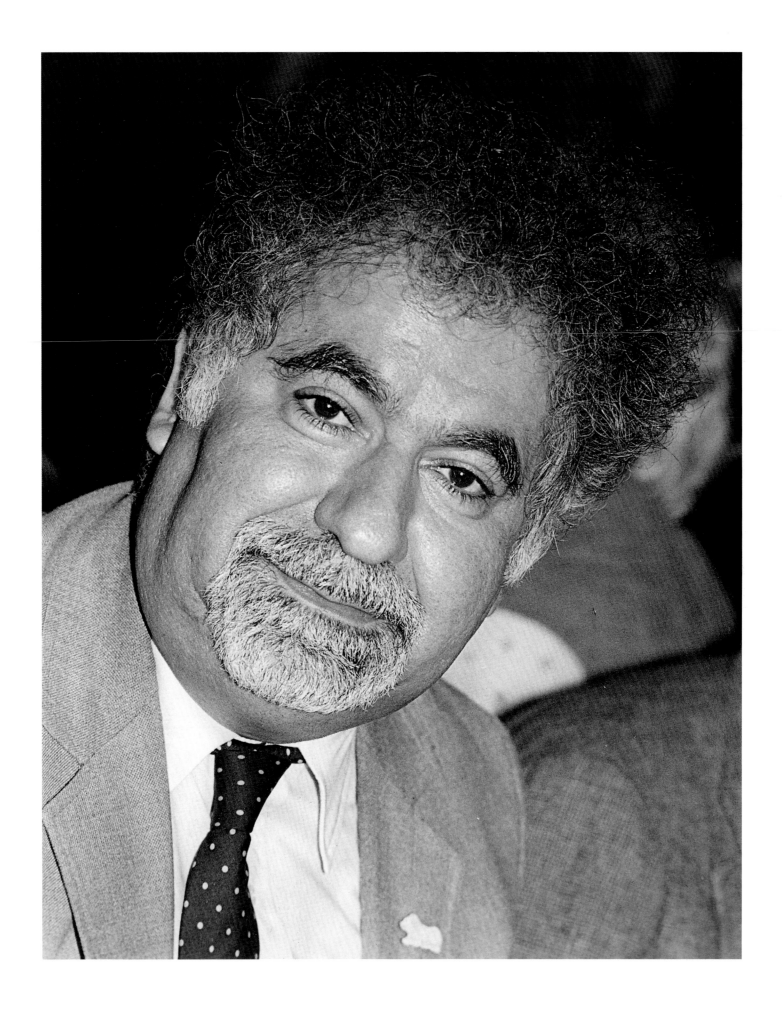

JEROME ROBBINS

The once and future white-haired boy. Our homegrown genius.

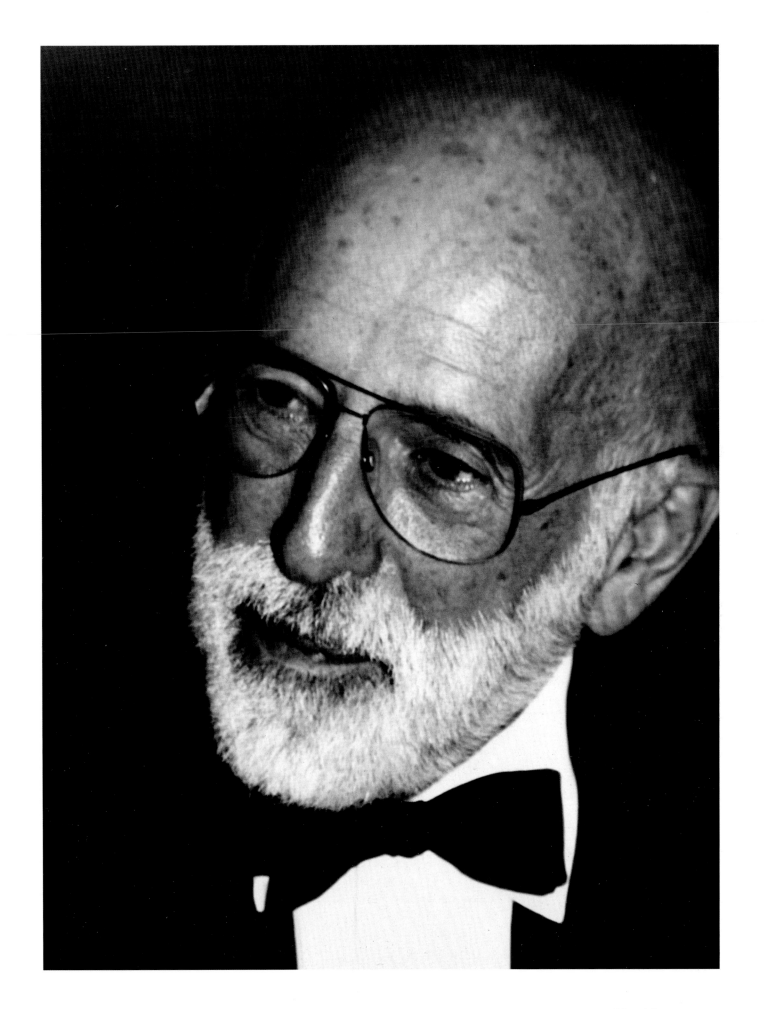

GRACE KELLY

At least age did not wither nor custom stale.
But midnight came much too soon.

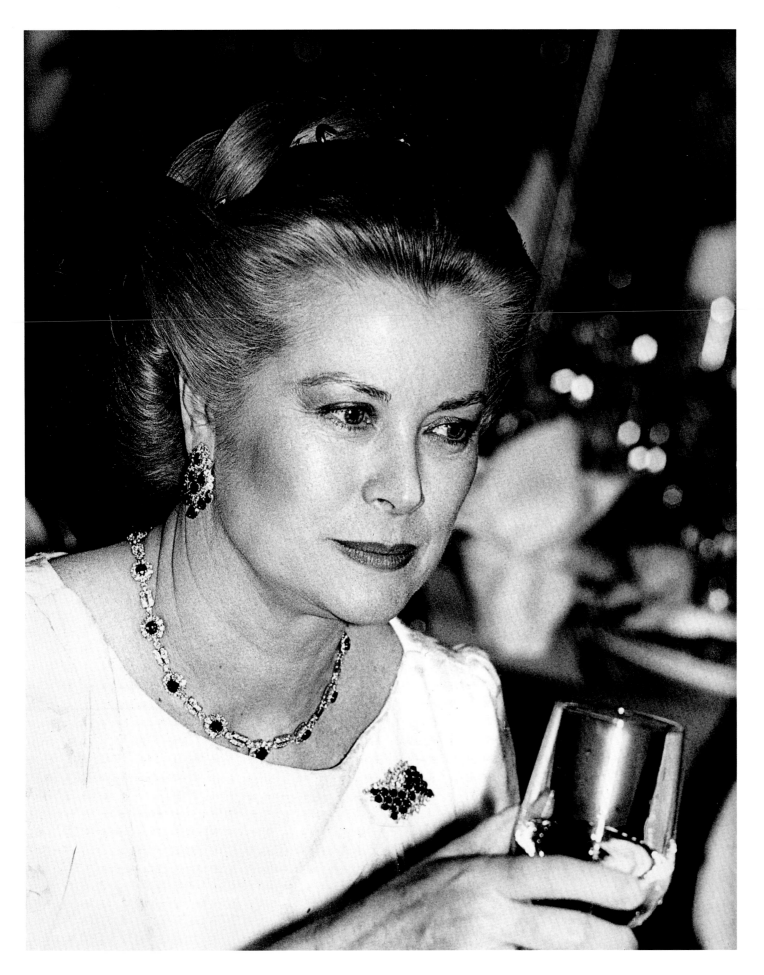

Grace de Monaco

Leonard Bernstein

All the excess love and energy persists.

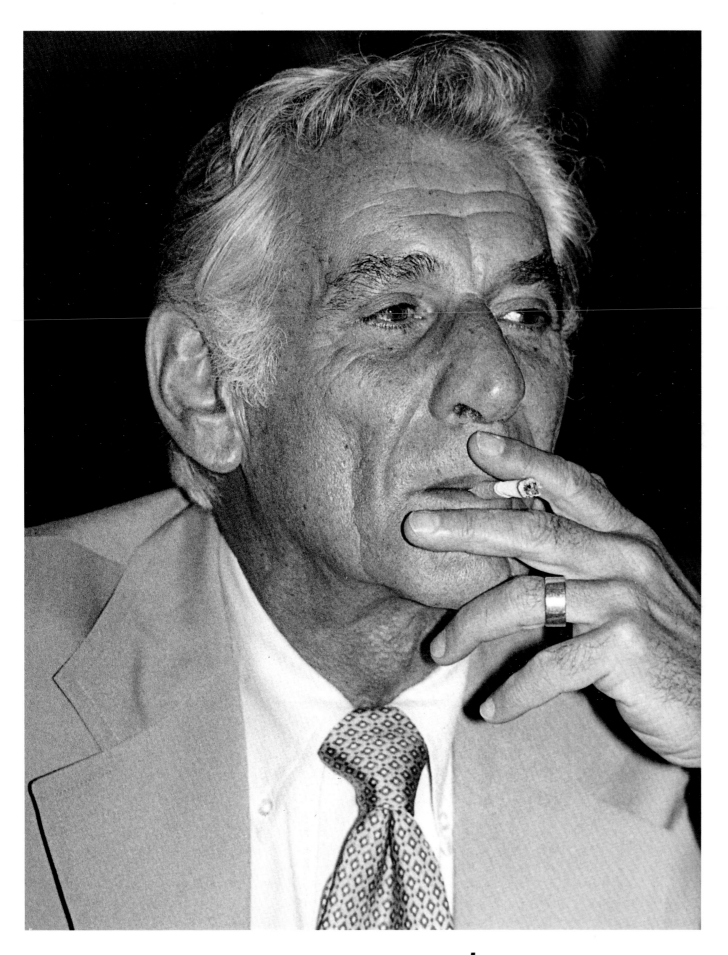

shirley maclaine

A floating star on an astral current.

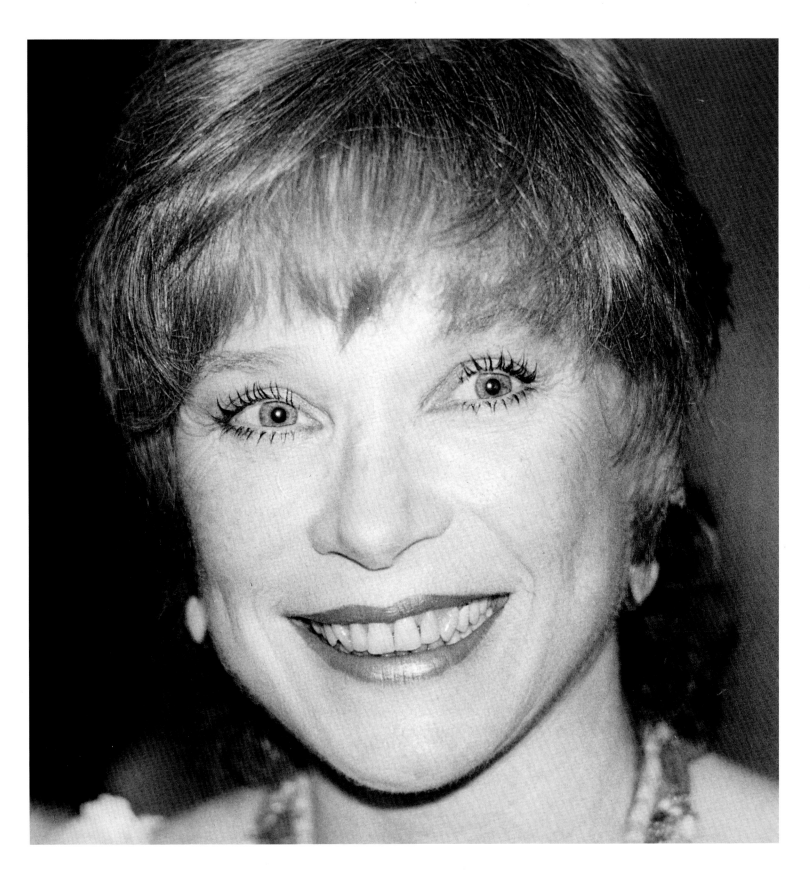

Le Roy Neiman

His painting could be better. This photograph is top drawer.

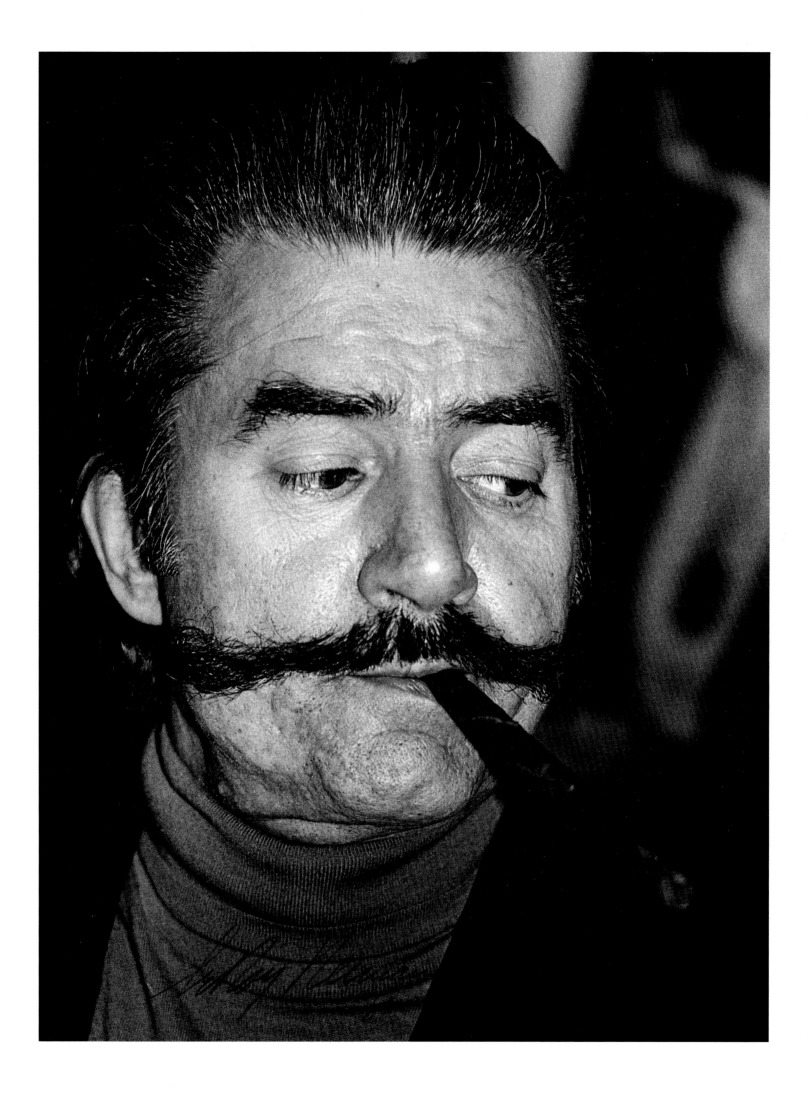

The other one. The one with the white suit.

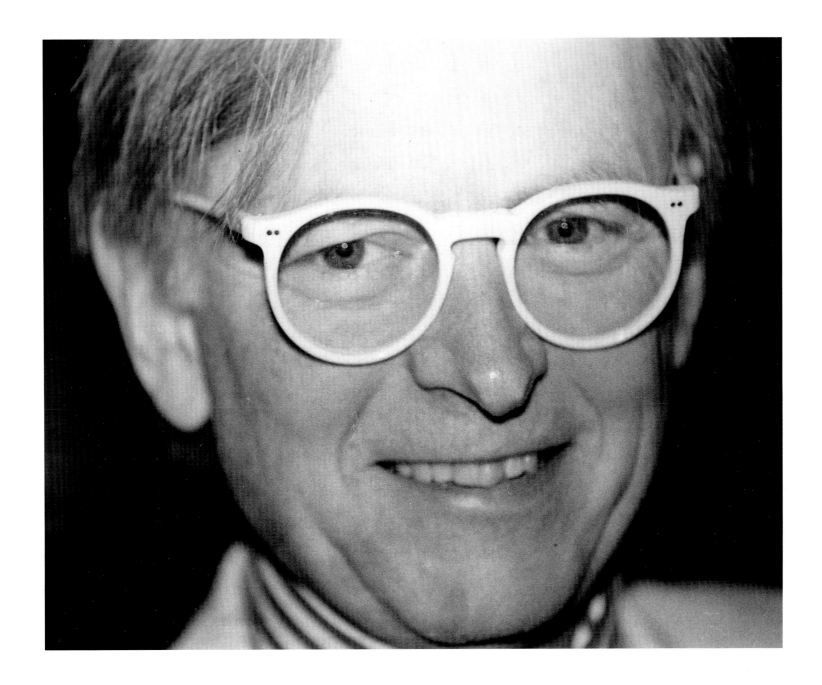

LENA HORNE

Flinty, sparkling, gorgeous. As the ad say: "Diamonds last forever".

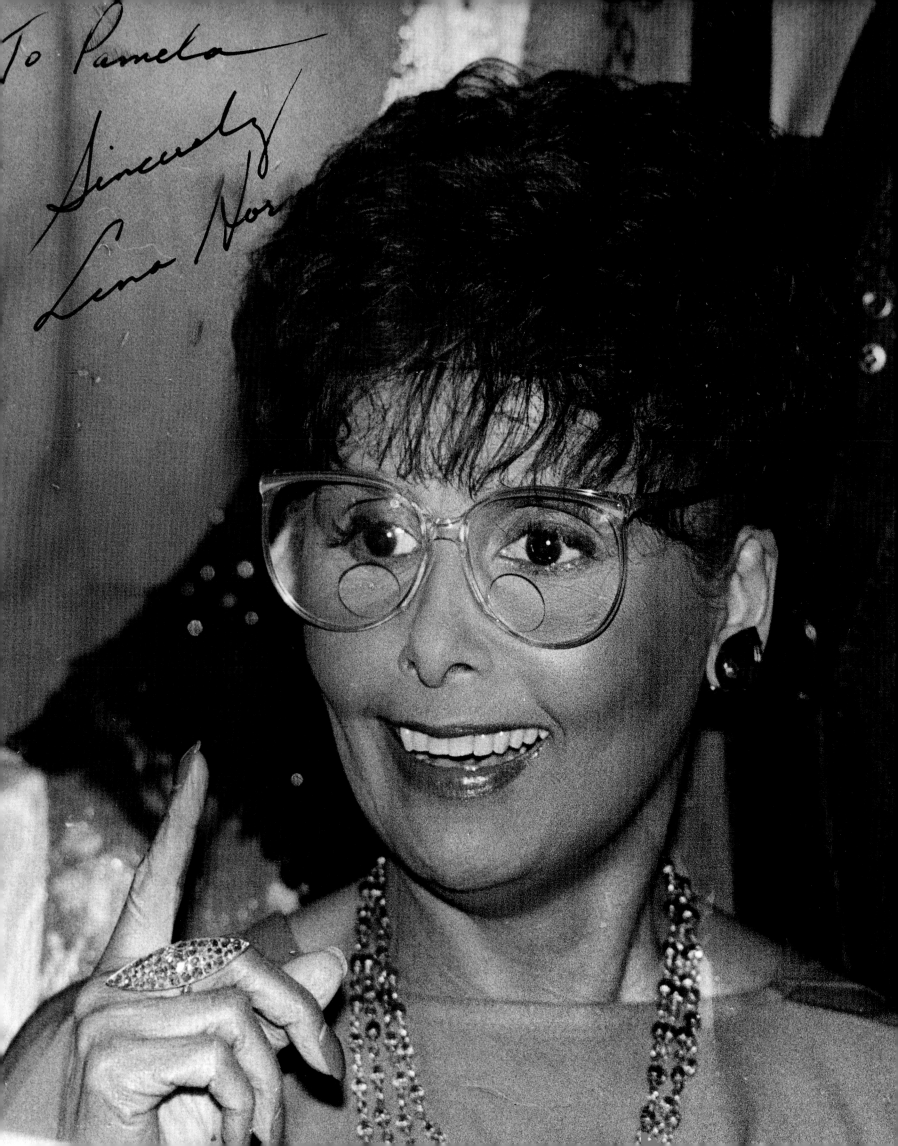

To Pamela
Sincerely
Lena Horne

Printed in Hong Kong by Pressroom Printer & Designer